ART UNFOLDED

A HISTORY OF
ART IN
FOUR COLOURS

Ben Street

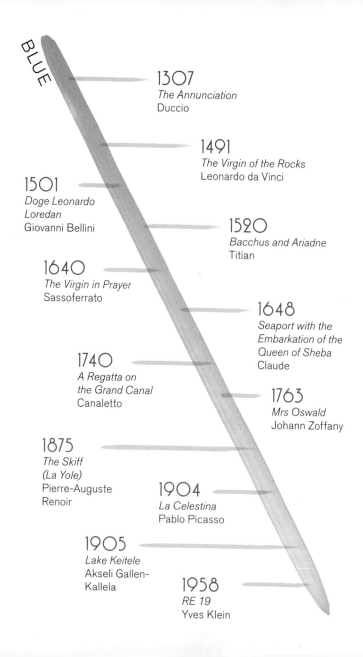

BLUE

1307
The Annunciation
Duccio

1491
The Virgin of the Rocks
Leonardo da Vinci

1501
*Doge Leonardo
Loredan*
Giovanni Bellini

1520
Bacchus and Ariadne
Titian

1640
The Virgin in Prayer
Sassoferrato

1648
*Seaport with the
Embarkation of the
Queen of Sheba*
Claude

1740
*A Regatta on
the Grand Canal*
Canaletto

1763
Mrs Oswald
Johann Zoffany

1875
*The Skiff
(La Yole)*
Pierre-Auguste
Renoir

1904
La Celestina
Pablo Picasso

1905
Lake Keitele
Akseli Gallen-
Kallela

1958
RE 19
Yves Klein

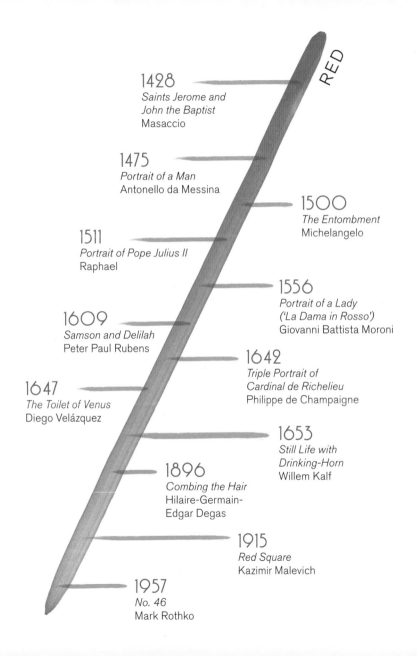

RED

1428
*Saints Jerome and
John the Baptist*
Masaccio

1475
Portrait of a Man
Antonello da Messina

1500
The Entombment
Michelangelo

1511
Portrait of Pope Julius II
Raphael

1556
*Portrait of a Lady
('La Dama in Rosso')*
Giovanni Battista Moroni

1609
Samson and Delilah
Peter Paul Rubens

1642
*Triple Portrait of
Cardinal de Richelieu*
Philippe de Champaigne

1647
The Toilet of Venus
Diego Velázquez

1653
*Still Life with
Drinking-Horn*
Willem Kalf

1896
Combing the Hair
Hilaire-Germain-
Edgar Degas

1915
Red Square
Kazimir Malevich

1957
No. 46
Mark Rothko

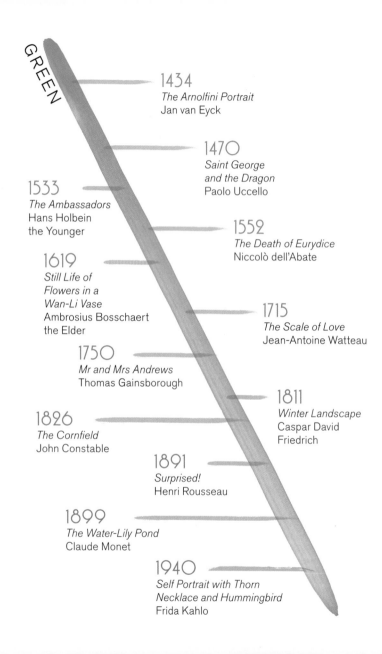

GREEN

1434
The Arnolfini Portrait
Jan van Eyck

1470
*Saint George
and the Dragon*
Paolo Uccello

1533
The Ambassadors
Hans Holbein
the Younger

1552
The Death of Eurydice
Niccolò dell'Abate

1619
*Still Life of
Flowers in a
Wan-Li Vase*
Ambrosius Bosschaert
the Elder

1715
The Scale of Love
Jean-Antoine Watteau

1750
Mr and Mrs Andrews
Thomas Gainsborough

1811
Winter Landscape
Caspar David
Friedrich

1826
The Cornfield
John Constable

1891
Surprised!
Henri Rousseau

1899
The Water-Lily Pond
Claude Monet

1940
*Self Portrait with Thorn
Necklace and Hummingbird*
Frida Kahlo

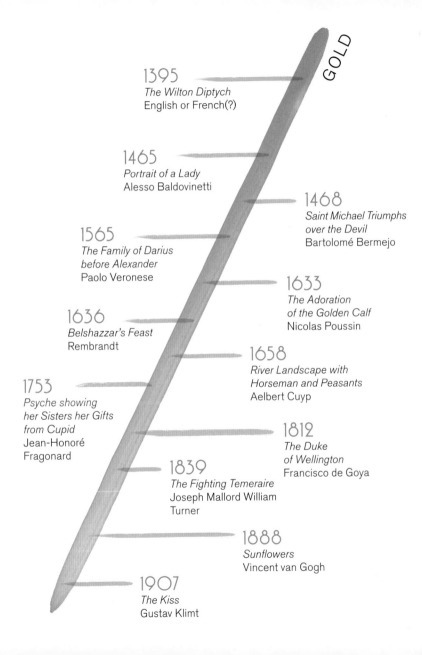

GOLD

1395
The Wilton Diptych
English or French(?)

1465
Portrait of a Lady
Alesso Baldovinetti

1468
*Saint Michael Triumphs
over the Devil*
Bartolomé Bermejo

1565
*The Family of Darius
before Alexander*
Paolo Veronese

1633
*The Adoration
of the Golden Calf*
Nicolas Poussin

1636
Belshazzar's Feast
Rembrandt

1658
*River Landscape with
Horseman and Peasants*
Aelbert Cuyp

1753
*Psyche showing
her Sisters her Gifts
from Cupid*
Jean-Honoré
Fragonard

1812
*The Duke
of Wellington*
Francisco de Goya

1839
The Fighting Temeraire
Joseph Mallord William
Turner

1888
Sunflowers
Vincent van Gogh

1907
The Kiss
Gustav Klimt

INTRODUCTION

We are immersed in colour

Everything we see and everything we touch has colour. From the very beginning of our life, colour determines how we interact with the world, helping us to identify objects around us and to navigate from one location to another. It is a part of the way we express our identity – personal, national, political – and so it is intimately bound up in the history of human life and our understanding of our place in the world. Yet colours are endlessly variable in their meanings. The colour red, for example, can convey danger, passion, warmth, anger, mortality, caution, embarrassment, error or happiness, and has any number of different associations depending on how and where it appears and who happens to see it. Even the very name is used to cover a range of shades within the same colour spectrum. The particular hue that flashes into your mind as you consider the word 'red' will be unique to you, the product of your own personal experience, imagination and memories. The fact that one colour can be at the same time evocative of something specific (a red flag, a red football strip, a flashing red light) and so infinitely diverse makes the study of colour in human history a fascinating way to think about what it means to be human.

The use of colour in paintings of the past is as wide-ranging and complex as human history itself. The exact same colour used by different artists in different paintings can express divinity, wealth or the artist's innermost feelings,

and sometimes all – if not more – of these at once. The stuff of colour – the raw pigment used in the manufacture of paint – is itself a window into economic and political contexts, encompassing the history of trade, exploration and exploitation. Our understanding of a colour is linked to our particular context, so we see (for example) the reds of the past differently from those who first saw them. Even the colours themselves are not quite what they were, since the chemical transformation of paint through time, and the altered environments and lighting they are seen in, mean that we are often seeing something different from what the artists originally intended. Because our relationship with colour is continually evolving, our experience of these paintings alters accordingly. Rather than alienating contemporary viewers, though, this ought to remind us that meanings change with time. On the other hand, learning about what a colour meant to the artist who used it transforms our understanding of both the colour and the work of art. Looking is always active, never passive.

From the very beginnings of human history people have desired to communicate using colour, seeking to reproduce it in enduring material forms for this purpose. The oldest pigment we know, a red colour in the powdered form of iron oxide known as red ochre, has been found in cave paintings and in burial sites across the world. Since then, naturally occurring colours – from minerals, stones, shellfish, clay,

'Learning about what a colour meant
to an artist who used it transforms our
understanding of both it and
the work of art.'

plants and insects – have been prepared through a process of drying and grinding and mixing with a binding agent to produce a substance that can be applied to walls, panels or canvases as paint.

For western cities, trade relationships and colonial expansion introduced new and exotic pigments, the use of which in a work of art then articulated the wealth and power of the place or person who had commissioned it. The revolutions in manufacture and transportation that characterise the birth of the modern world left their mark in the invention of industrially produced pigments. New forms of image distribution – photography, cinema, television, the computer screen, the Internet – have further expanded the spectrum of colours present in our daily life and available to our imagination. Because colour is a mirror of the way a society sees itself, through it we can trace a path from the distant past to the living present.

This book takes four different routes through the history of colour in Western painting, starting in the fourteenth century and finishing in the twentieth. The colours blue, red, green and gold have been chosen not only because they are widely used in Western art but also because they have powerful and lasting associations. These are colours that have retained their influence, their various meanings still recognisable in almost every image surrounding us

'Painters of the past understood
the power of colour just as do the
advertisers or politicians of today.'

today. Their effects can be subtle, even subconscious, but they remain a persuasive part of how we engage with the world. The painters of the past understood the power of colour just as do the advertisers and politicians of today: like music, colour is a language beyond words that speaks directly to our emotions. For all the artists featured in this book, colour was a principal part of what their painting was intended to express, from visions of the afterlife to dreams of ideal societies, from earthly authority to divine power, and from realistic and symbolic images of the natural world to glimpses of the inner life of the artist or their subject.

In the West, the colour blue has long been associated with religious painting. During the Middle Ages and the Renaissance, the most brilliant blue was by far the most expensive colour to use and, as a consequence, tended to be used for the most important figures in a composition. Like many paints, blue was composed of pulverised matter suspended in a medium, and in the oldest paintings in this book that blue matter was often a semi-precious stone, lapis lazuli. When artists began to be interested in landscape backgrounds in their paintings, blue became a useful means of evoking distance. As we look at it, the cool shades of blue seem to recede from us, especially in comparison with warmer, more strident colours like red and yellow, which tend to pop out of paintings. The most distant points

in painted landscapes are often painted blue in an attempt to mimic the natural appearance of real space; but blue is also used to symbolise the divine, similarly out of reach.

Green is an altogether harder colour to pin down. Not a primary colour, it could be made from a mixture of blue and yellow, but the pigments used to make pure green were often unstable, sometimes changing their colour over time. The chemical unreliability of the colour carries over to its symbolic associations in paintings: it was often used to depict the devil and other manifestations of evil. Yet green is also the colour of new life and so it was often used in reference to pregnancy and childbirth. As the dominant colour of the plant kingdom, its links to the natural world are long-standing, but green came into its own with the development of the landscape genre in painting in the sixteenth and seventeenth centuries. Green's ambiguity as a colour remains true to this day. Standing for both sickness and health, the newly born and the long dead, green occupies shifting ground.

Like the other colours, red brings with it a range of associations, but it is rarely anything other than forceful in its impact, advancing forward where other colours recede. Red became omnipresent in Christian paintings due to its connotations of blood and fire, both potent symbols in Christian theology. Intensity is always implied in the

use of red, whether as a way of suggesting the inner fire of a sitter in an otherwise staid portrait or of implying a strong emotional undercurrent in an apparently restrained narrative. Far from the pure, chaste blood of the faithful, red is of course also the colour of desire. Red-blooded passion may be overt or hidden, but the colour signals a warning and may well make the heart beat a little faster. Used with green, its complementary colour, red's heat is turned up. Used on its own, pure red evokes raw and powerful feelings, be they spiritual, emotional or political.

Of all the colours discussed in this book, gold is the one whose associations have remained relatively consistent over the centuries. Luxury, power, materialism: gold has embodied some or all of these for thousands of years. Because gold naturally reflects light, it was understood to have something of the quality of the sun, and since a radiant sun has been a constant image of the divine, from Ancient Egyptian gods through to sculptures of classical deities and the glittering haloes of Christian saints, various religions have used gold in their sacred art. Even when artists replaced real gold leaf with simulated gold composed of yellow, brown and orange paint, they strove to replicate the radiant effect, and traditional associations remained. Yellow's brilliant clarity could stand for gold, calling to mind its ancient usage and generating a radiance comparable to the precious metal itself.

'Colour unlocks the history of our changing tastes, the transformation of spirituality, our evolving relationship with the natural world, and even political revolution.'

Because paintings preserve colour better than almost any other artefact, they grant us access to the history of colour in human society, collapsing the distance between then and now. Colour unlocks the history of our changing tastes, the transformation of spirituality, our evolving relationship with the natural world, and even political revolution. This book covers a time of seismic shifts in western history, from the fourteenth century to the twentieth, with colour as the key. London's National Gallery, from which most of these paintings are drawn, is home to one of the outstanding collections of western European paintings in the world. As such, it is the ideal place to explore the history of art through colour, and the history of human experience through art.

Colour establishes both difference and continuity in human history. Through it we can trace the changing functions, styles and subjects that make the history of Western art so enthralling. Just as importantly, the recurring interest in certain colours, from medieval times to nowadays, reminds us of the interconnectedness of the past and the present, like coloured threads that reach backwards and forwards in time. Colour, then, is a perfect means of understanding not only art, but also the world and our place within it.

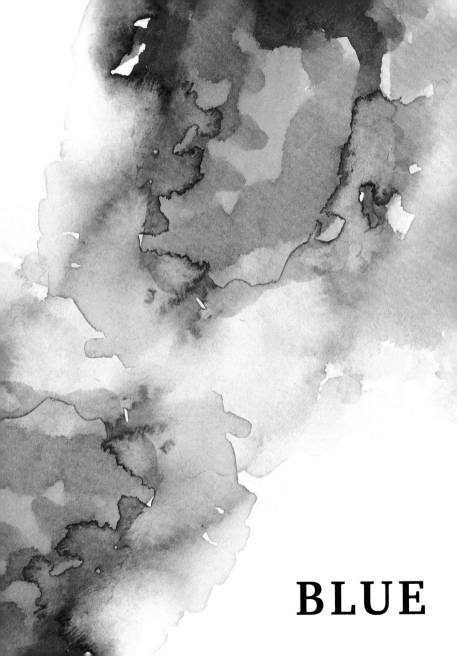

BLUE

Blue is the colour of longing

It is everywhere around us and yet somehow always just out of reach. It is the colour of the sky above us, yet the blue of the sky is not something that can be seen up close: it lies only in the untouchable depths and farthest distances. This elusive quality might in part explain its appeal to artists. When wanting to suggest the ineffable divine, blue is the colour of choice. Blue's natural optical qualities make it the ideal way to express such notions.

Blue is a cool colour that recedes when used in a painting. Artists seeking to illustrate deep distance, things at the very extent of visibility, turned to blue. It is the colour of experiences that lie beyond the ordinary: the intangible, the inaccessible. At the same time, blue is the colour of extraordinary wealth and luxury. From the fourteenth century until the invention of Prussian blue at the turn of the eighteenth century, the favoured blue pigment was ultramarine. Made of lapis lazuli, a semi-precious stone available only in Afghanistan, it had to be mined then transported at considerable cost and effort to Europe, where it was crushed into a powder and mixed with a medium before being ready to use. As a result, blue was at one time more expensive than gold.

The Annunciation

Duccio

1307/8–11

No colour is only a colour. Every colour works on a symbolic level too, and when used in paintings such as this one, blue suggests a glimpse of the divine. We're witnessing the moment when the Virgin Mary receives the news of her imminent pregnancy from the Archangel Gabriel. The two figures are subtly separated using a series of open arches. That division of space is another means of telling the story. A thin grey column divides the winged angel and the startled woman, who has been interrupted in the middle of reading. Mary is depicted in a deep blue cloak fringed with gold over a red dress, and her head is covered with a white cloth. Red, the colour of blood and the body,

SEE ALSO
Leonardo,
Sassoferrato,
The Wilton
Diptych

stands for her mortality and her son's future suffering on the Cross; white for her virginity, retained despite the fact that she gives birth; and gold for her regality – she becomes Queen of Heaven after her death. Her deep blue robe stands, as it always does in paintings of Mary, for her spirituality. Gabriel wears a lighter blue, under a lilac cloak, and at the top edge of the painting, between the two figures, is part of a blue disc, standing for God. To the medieval imagination, blue's association with deep distance – the sky, the sea – made it the perfect way to suggest the world of the spirit, far from everyday life. Blue, an expensive pigment used sparingly, would also mark out a figure as being especially significant. For Christians, the Annunciation – news of the pregnancy of Mary and the birth of Christ – is the moment when the spiritual and the everyday came together. The meeting of those two worlds is the real theme of the story.

1307

The Virgin of the Rocks

Leonardo da Vinci
1491/2–9 and 1506–8

A group of figures are gathered in a cave-like space, seeming to communicate with each other through a series of interconnected gestures. The Virgin Mary, dressed in blue to denote her spirituality, rests her right hand on the back of a young boy, whose camel-skin shirt and spindly cross identify him as John the Baptist. John blesses Mary's son Jesus, who blesses him in response. Behind Jesus, and supporting him, is an angel looking off into the distance. The Virgin's position makes her the apex of a triangle that encapsulates the other figures. This is a symbolic shape, calling to mind the Holy Trinity of Christian theology, but it also creates a balanced structure within the painting. This approach was often used by artists of Leonardo's time, and yet, as you might expect, Leonardo moves far beyond these conventions in other ways.

SEE ALSO
Duccio,
Michelangelo,
Raphael,
Sassoferrato

Leonardo deviated from the traditions of depicting religious figures by placing the group within a complex and naturalistic rock formation. As no Christian narrative describes the scene, no previous painter had ever thought to use such an unorthodox setting. Those distinctive crags, each one rendered with precision, are surely based on the artist's observational drawings of natural forms in his native Tuscany. From the light glinting in the iris of the angel's eye to the clusters of flowers at the feet of John, every element of the painting is the fruit of Leonardo's scientific analysis of the organic world, gathered together in his celebrated sketchbooks. This revolutionary approach to a timeless subject was to be hugely influential on later generations of artists.

Seen in its original location in a chapel in the church of San Francesco in Milan, the painting would have a very different and more dramatic effect than it does now. Illuminated by candles and surrounded by an ornate gold frame, the painted figures would appear to emerge from the cave and seem to enter the gloom of the chapel itself. The mysterious narrative of the painting would seem to be unfolding in real time, before the onlooker's very eyes. Leonardo's scientific precision and innovative treatment of the story serve the religious function of the painting: this is the divine brought to powerfully naturalistic life.

Behind the figures, through a gap in the rocks, our eye is led into the far distance. The technique of gently grading the greens and blues is known as aerial or atmospheric perspective, an effect developed by Northern European painters. This mimics the way we actually see the world. As objects recede from us, their colour fades and their internal contrasts are less marked. Leonardo's distinctive approach was known as *sfumato*, or 'seen as if through smoke', and the contrasts of tone within the painting do have a hazy, smoke-like quality. The effect is of a gradual appearance, rather than stark illumination, as though the figures in the painting are emerging out of a fog. Leonardo seeks to replicate these natural effects in order to bring the narrative of the painting closer to our own experience of the world. He creates the illusion of depth by contrasting the sharp clarity of the Virgin's face with the fuzzy blues of the distant mountains. The effect is all the more intimate for that. Even now, the mystery of the painting compels us to silence as we look.

Doge Leonardo Loredan

Giovanni Bellini

1501–2

1501

The bright blue of the background brings the sitter's features into sharp relief. Lit from the left, his face takes on a three-dimensional quality, becoming a physical object we could hold in our hands. His face displays a combination of steely resolve and contemplative observation. Bellini's use of light suggests these different facets of the sitter's character. This is a portrait of Leonardo Loredan, the doge, or chief magistrate, of the Republic of Venice, portrayed in his robes and hat of state, or *corno*. In this work, Bellini, at the time the most successful and sought-after painter in Venice, touches upon the power and poignancy of Loredan's position. The sitter exudes authority, yet remains physically slight, even frail.

The blue, applied in layers of thin glaze, is exceptionally lush and radiant, and is full of subtle tonal range as it lightens towards the doge's shoulders; but it is much more than a mere background. In order to make it, the artist's assistants would first have pulverised lapis lazuli, then mixed it with oil. Grinding the hard rock into a fine powder was exhausting and time-consuming work, but no other blue was as rich or fine as that produced by lapis. At the time, this type of blue pigment was even more valuable even than gold, since the lapis from which it derived had to be imported to Italy from Afghanistan. The journey to acquire it inspired the evocative name still used for this dense, luxurious colour: ultramarine, meaning 'beyond the sea'. Because Venice was the entry point into Europe for many goods from the East, including lapis, painters there made full use of ultramarine to express the wealth and power of the Republic. Doges and dignitaries were portrayed in, or surrounded by, fields of ultramarine. Private patrons specified the amount of the colour to be used in works they'd

commissioned. Paintings hanging in churches radiated rich blues to suggest both spiritual intensity and extraordinary wealth. The colour reflected back to the people of Venice the remarkable authority of the Republic. Little wonder that the Venetians believed themselves to be specially blessed by God. The beauty of their city, and the works of art within it, were evidence of that.

However, the wealth of Venice was carefully controlled. The doge might be portrayed in wildly expensive clothing – those shimmering robes, with their pineapple pattern, are made of damask silk, imported from the city's trading partners in the East – but he is placed behind a stone ledge, as though hemmed in by it. Doges were always elected towards the end of their life, so that their tenure would be relatively short: a high turnover of doges meant tyranny could be avoided, and mostly it was. Venice's complex political system and active espionage network, both professional and otherwise, ensured that no one person could dominate the city. Spying on your neighbour was considered an act of service to your city.

SEE ALSO
Holbein,
Titian,
van Eyck

Loredan has been compared to a chess piece in this painting, which is an appropriate analogy for the actual power of the doge. By not showing his arms, Bellini emphasises his ceremonial, rather than political, status. He seems strapped into his role, almost straitjacketed. So the wealth implied by that silk and even more so by that expanse of blue is a reflection not of Loredan's power, but of the power of Venice, the Republic of which he was, really, only the figurehead. This could be a portrait of Venice itself, embodied temporarily by a weak, if determined, old man.

Bacchus
and Ariadne

Titian

1520–3

Brilliant blues in a range of tones fill this remarkable painting, from the luxurious robes of the female figures to the rich expanse of sky and its bands of chalky clouds. Other colours pop against the blue, the oranges, reds and pinks of drapery vibrating in harmony with it. The overall effect is of a controlled explosion of sensual and dynamic colour that blazes from the wall of the gallery. Here, richness of colour implies richness of patron, and the expense of all that ultramarine, made up of ground lapis lazuli mixed with an oil binder, acts as a flattering mirror of the man who paid for it.

Alfonso I d'Este, the Duke of Ferrara in northern Italy, commissioned the young Venetian artist Titian to paint a series of mythological scenes for the walls of his private study, or *camerino*. For patrons such as Alfonso, paintings that depicted scenes from classical mythology conveyed the intellectual sophistication of their owners. Few people at the time were literate, let alone familiar with classical stories, and so the choice of subject singled the patron out as a member of the intellectual elite. Titian's painting succeeds in communicating the wealth and scholarly pretensions of Alfonso, and adds a carnival-like atmosphere that conveys a world of carefree hedonism that would certainly have appealed to the patron, though he might have been reluctant to admit it.

Titian's painting explores a narrative told in the work of two Roman writers, Catullus and Ovid. In the story, Bacchus, the god of wine, falls in love with the mortal princess Ariadne, who has been cruelly abandoned on the island of Naxos by her lover, Theseus, after she helps him defeat the Minotaur. Titian depicts Bacchus, his eyes

wide and cheeks flushed, on the verge of toppling over as he catches sight of the beautiful Ariadne. Literally falling in love – one leg is frozen in mid-air as he tumbles off his chariot – Bacchus gestures behind him, seeming to invite Ariadne to join his entourage. Ariadne, meanwhile, is caught in a complex twist, waving frantically to Theseus' departing boat and turning her head as she catches sight of the god for the first time. The moment of their eyes meeting is like a pause in the painting, where time stands still across a gentle expanse of blue. Above Ariadne, sparkling against the clear blue sky, is a ring of stars: this is her wedding gift from Bacchus, who will transform her into a circular constellation when she dies.

By contrast with this tender moment, Bacchus' entourage of semi-human creatures romps behind the god, oblivious to the love story unfolding beside them. These creatures – a goat-legged faun dragging a cow's head, a horned man wrapped in snakes, a furry-thighed character waving the cow's severed leg – partly derive from Titian's study of classical art. The complex shapes and tonal contrasts of their dancing bodies acts as a counterweight to the still, suspended moment between the god and the girl. As though aware of the high quality of his interpretation of this ancient tale, Titian signs his name on a gold trophy that is casually leaning at the bottom left corner – in Latin, to associate himself with the greats of the classical past. Painted not using real gold leaf, as earlier generations of artists had, but in shades of yellow, brown and white, the trophy is a showcase for the artist's powers of transformation.

SEE ALSO
Bellini,
Bronzino,
Fragonard

1520

The Virgin in Prayer

Sassoferrato

1640–50

Few blues are as potent as that of the Virgin Mary's robe in this work. True to convention, she wears the three colours that are associated with her: white for purity, red for mortality and blue for spirituality. Sassoferrato seems to emphasise the latter aspect by using quantities of precious ultramarine. Thanks to the blue's brilliance, Mary's spiritual power radiates from the painting as though literally emitting light. Her hands lightly touching in prayer, the Virgin lowers her head and her eyes, illustrating another principal aspect of her character: humility. She does not meet our gaze, and with her face partly in shadow, seems to encourage us to contemplate the praying hands, perhaps to encourage us to do the same. Sassoferrato has eliminated any narrative context that might explain her self-effacing pose; instead we're simply asked to focus on the pose itself, to contemplate its meanings and to be spiritually guided by it.

SEE ALSO
Duccio,
Leonardo,
Bellini

Sassoferrato's sweet and tender paintings of the Virgin Mary were especially popular in Rome, where the artist worked. The simple design and emotional force of the image was such that Sassoferrato made many versions of it, perhaps as many as fourteen. Because of their small scale, such paintings were much more affordable than most paintings made at this time, and were usually bought already made, rather than commissioned. Pilgrims might purchase one to bring back to their home countries. This painting can be imagined hanging in a domestic interior or on the wall of a monastery or a convent. Its combination of dazzling colour and quiet concentration is enough to induce silence and contemplation.

Seaport with the Embarkation of the Queen of Sheba

Claude
1648

Landscape painting as a genre in its own right was a novelty in seventeenth-century Italy, where this painting was made, and it took two émigré Frenchmen to develop it: Claude Lorrain and Nicolas Poussin. Claude's painting was commissioned by the Duc de Bouillon, the general of the papal army in Rome, as one of a pair depicting scenes from the Old Testament. Claude's painting places the pink-robed queen, strangely diminutive in the middle distance and to the right, as she is led down to the small boat that will take her to the large one waiting to the left, visible between the columns of a ruined temple. What seems of greater interest to the artist is the depiction of morning light as it fills the sky, dances on the water and illuminates the classical architecture.

Claude is known to have taken countryside walks outside Rome, with sketchbook in hand, and this painting shows the results of his careful observations of natural phenomena. The gently graduated blues of the sky are in striking contrast to the deeper tones of the lapping sea. As our eye travels into the deep space of the painting, helped along by diagonal lines such as the marble dock that lead our gaze, delicate blues soften the edges of the buildings and boats. The humped island in the distance feels very far away: it's painted with the very haziest of light blues and yellows. The technique Claude has employed is aerial or atmospheric perspective, a way of suggesting distance through colour and tone that mirrors how we see in reality, with faraway buildings and trees receding into a grey-blue as they reach the horizon.

SEE ALSO
Friedrich,
Leonardo,
Poussin

1648

A Regatta on the Grand Canal

Canaletto
about 1740

Canaletto graciously positions us high above the scene for the best possible view of this event, the annual gondola race along the Grand Canal during the Venetian carnival. Spectators gather to watch, the very wealthiest peering from ornate golden barges, while others cheer from the banks or the high windows of buildings. The race itself passes down the centre of the canal and ends at the Rialto Bridge, just visible in the distance. As much as anything, the regatta was an opportunity to socialise, and the groups at the front left, standing on a temporary wooden structure, seem mostly lost in idle chat.

Canaletto paints the canal in pale greyish-blues, delicately shadowed and overlaid with a light pattern of tiny waves, contrasting with the bright, cloudy sky that takes up half the scene: the effect suggests an expanse of glassy water. His ability to capture the quality of the Venetian light and his mastery of *vedute* (paintings of picturesque views, of which this is an excellent example) made Canaletto hugely popular with visiting British aristocrats. Travelling through European cities on the eighteenth-century

SEE ALSO
Claude,
Poussin,
Renoir,
Monet

Grand Tour, they would buy paintings such as this one as souvenirs to hang on the walls of their stately homes. This painting, with its combination of local detail and somewhat stylised and romantic atmosphere, seems squarely aimed at the sensibilities of these visitors, the precursors of the modern tourists who throng the same location today.

It seems strange that a painter best known for his views of Venice's famous canals should be called Giovanni Antonio Canal (Canaletto was a nickname, meaning 'little canal', after his father, Bernardo Canal), but it's true.

Mrs Oswald

Johann Zoffany

1763–4

Mary Oswald is depicted in a shimmering blue taffeta dress with wide lace sleeves, which was the height of fashion at the time. The rich blue of Mrs Oswald's dress serves to emphasise, by contrast, her pale skin and high forehead, made paler by the addition of powder and pink blusher. That expanse of colour was painted using Prussian blue, a pigment invented just over fifty years before this painting was made. Prussian blue is sometimes called the first synthetic pigment, since it was developed (by chance) through a chemical reaction in a laboratory rather than deriving from a mixture of organic materials. The stability and strength, as well as the affordability, of this colour made it hugely popular with painters well into the nineteenth century.

Paleness of skin was much desired at the time this painting was made. A light skin tone implied that the sitter was usually to be found indoors and was therefore wealthy, unlike those of a lower social class, who made their living working the land and so were more likely to have tanned faces and hands. Here, the artist locates the sitter outside, associating her with the beauty and abundance of the natural world – although she would certainly have sat for the painting in the artist's London studio, with Zoffany adding the background later. The difference of lighting between Mrs Oswald and the tree is a hint of this, though probably not a deliberate one.

SEE ALSO
Gainsborough,
Reynolds,
Moroni

Mrs Oswald herself was born into extraordinary wealth. Her father was a Scottish landowner in Jamaica, where she was born, and her husband, Richard Oswald, owned a trading empire based in the West Indies, much of whose wealth was built on the transatlantic slave trade.

1763

The Skiff (La Yole)

Pierre-Auguste Renoir

1875

It takes quite a feat of imagination to see a painting like this as shocking, but there was a time when Renoir and his Impressionist colleagues were considered scandalous. When the group first exhibited their works, the critical response was a mixture of outrage and amusement. This painting epitomises what it was that so riled his early audiences. Made quickly, with dabbed marks, the painting has an appearance of being unfinished – at least by the standards of its day. Renoir's painting blurs the boundary between a sketch and a finished work of art that had been a basic principle of painting for generations before his. The term 'Impressionist' actually derives from a negative review of the first exhibition by the group, which took place in Paris in the year before this painting was made. Referring to the loose, incomplete style of

SEE ALSO
Gallen-Kallela,
Monet,
Degas

paintings such as this, the critic Louis Leroy coined the term as a mark of derision, little knowing that it would become an influential and wildly popular style by the turn of the twentieth century.

In this painting, a couple in a rowing boat are depicted passing across shimmering blue water on a summer's day. They have passed under a bridge, over which a puffing steam train is about to pass. The effect is not that of a specific scene or characters, the intention is rather to recall the atmosphere of a blazing-hot afternoon and the impression of movement and light as registered by the eye of an onlooker. Capturing the quality of light in a scene was one of the key concerns of the Impressionists, and that's exactly what this painting does. Renoir's swift, loose marks ripple lightly on the surface of the canvas, representing the movement of light and water, steam and cloud, and evoking the transience of the scene itself.

Painting outside, known as plein-air painting, was an approach used by many of the Impressionists, including Renoir. While earlier landscape painters often sketched out of doors, the final version of a painting was always made in the studio. Impressionists such as Renoir placed a new emphasis on the subjective experience of a scene in the moment, and recorded their surroundings with unusual freshness and spontaneity. Modern technology was essential to this development. Oil paint came pre-mixed by this point, and was sold in metal tubes, rather than needing to be carried around in animal bladders as it had in the past. Collapsible easels allowed the artist to set up his or her canvas wherever suited them. Modern transport, too, was important. Living and exhibiting in Paris, the Impressionists took advantage of the spread of railway lines into the countryside, heading out for a day's painting and returning the same day.

Renoir's painting also shows the influence of new ideas in the science of optics. In his depiction of the water he used cobalt blue, a synthetic pigment invented in the early years of the same century, which was particularly popular among his fellow Impressionists. The chrome orange used on the boat is a complementary colour, which creates an optical effect when juxtaposed with blue: they are mutually enhanced, giving the blue an added intensity that evokes the brilliant light of summer. Though complementary colours and their effects had long been understood by painters, the new colour theories of the chemist Michel Eugène Chevreul, which laid out the principles of colour relationships, had a striking effect on the painters of the late nineteenth century. This painting is both an impression of idling on a summer's day and an exploration of the effects of colour on the human eye, somewhere between science and sensation.

1875

La Celestina

Pablo Picasso

1904

Few artists have mined the emotional language of colour with greater single-mindedness than Pablo Picasso during his Blue Period. Inspired in part by the tragic suicide of his friend Carlos Casagemas in 1901 and in part by the destitute characters he encountered in Barcelona and Paris, the Blue Period is characterised by a marriage of a sombre, largely monochromatic palette and bleak subject matter. Penniless himself at the time, Picasso identified with the social outcasts and drifters he met in the various bars and cafés he frequented. Every colour in *La Celestina* is a variation on blue, lending the painting its cold and wistful atmosphere. The title of the painting refers to a fifteenth-century Spanish play by Fernando de Rojas, featuring a devious and sly procuress (a

SEE ALSO
Baldovinetti,
Moroni,
Champaigne

'madam' in modern parlance). Whatever her real profession, this was certainly a woman Picasso met in one of his preferred Barcelona nightclubs, the Eden Concert. Picasso wrote the club's address on the reverse of the canvas, along with the woman's name: Carlota Valdivia. Picasso is unflinching in his treatment of Carlota's old age, showing tufts of grey hair around her mouth and chin, and turning her head to give her blind left eye prominence in the painting. Despite this, she is given the prepossessing bearing of a queen in a royal portrait, the lace lining her hood and glint of a pearl earring suggesting a faded, if not entirely abandoned, glamour. The slight pink flush to her cheeks implies a memory of youthful vigour, just visible beneath the sagging skin. And yet the deep blue palette floods the portrait with a melancholy mood, giving her slight smile an ironic quality. The woman seems irrevocably trapped, as though seen underwater, hopelessly distant from the bright pleasures of conventional life.

Lake Keitele

Akseli Gallen-Kallela

1905

Like an Impressionist painting, this landscape attempts to capture the fleeting effects of light and air on the natural world. We see an expanse of water that is both rippled with tiny waves, breaking up the reflections of the sky and trees, and distorted by lateral grey streaks that rub them out completely. Together, these touches suggest the transitory effects of strong wind on a body of water, a phenomenon that almost gives the painting the contrasting impressions of both extreme stillness and brisk movement, so effectively placing the viewer within the scene that you can almost feel the wind on your skin as you view it. The simultaneously calm and mysterious atmosphere is generated partly by a composition that takes the eye travelling over a range of subtle variations of blue, from the grey-blue of the water comprising the greatest part of the painting to the darker blues of the distant hills and that intense slice of cloudy blue sky at the very top.

Finnish artist Gallen-Kallela painted this scene of a lake in central Finland on several occasions, intrigued by its serene quality. More important, perhaps, were the symbolic associations of such a vista. Until 1809, Finland had been controlled by Sweden and it became fully independent only in 1917, twelve years after this painting was made. Gallen-Kallela rooted his paintings in recently unearthed Finnish mythology, which had been collated into a collection entitled the *Kalevala*. A key character in the *Kalevala* was Väinämöinen, a mythical fisherman, boat-builder and singer. In Finnish, those grey stripes that zigzag across the water are referred to as 'Väinämöinen's Wake', the last traces of the hero's final journey. Gallen-Kallela brings together the natural and the mystical in a painting that is both careful observation and poetic, even political, statement of intent.

SEE ALSO
Renoir,
Monet

RE 19

Yves Klein

1958

For some artists, colour is the subject as well as the medium of their work. Yves Klein was such an artist, for whom the purest colour blue was an end in itself. His quest for the perfect blue led to him successfully patenting a deep ultramarine blue in 1957. Klein had found that the specific tone of the raw pigment was changed when mixed with a medium, so he worked with a chemical manufacturer called Rhône-Poulenc to find a binder that would retain ultramarine's intensity when made into paint. Eventually he found the ideal medium: polyvinyl acetate resin, and the name he gave the resulting colour was International Klein Blue, or IKB. Klein made a series of monochromatic paintings, applying the colour evenly with a roller or a sponge for a matte effect that negated the expressive brushstrokes

SEE ALSO
Rothko,
Bellini,
Malevich

of most abstract painting at that time. Because the artist's hand is nowhere evident, the viewer is able to experience the pure blue in a direct way, unmediated by an artist's psyche, mood or physicality. For Klein, the colour blue had an immaterial quality, evoking the infinite depth of a clear sky. It also suggested spirituality, as it had for medieval and Renaissance artists; as a devout Catholic, Klein was certainly aware of that tradition, and seems to have been intent on creating a modern form of spiritual art. He also used gold leaf in some works, in a similar nod to the art of the past. One day, Klein noticed how the sponges he used to create his monochromes had utterly absorbed the blue, and set about using them in his work, sometimes as standalone objects, sometimes affixed to the surface of a painting, as in this work. He saw the sponges as representations of the viewers of his paintings, who would become filled with the sensibility of his art and transformed by it.

1875

The Skiff (La Yole), 1875
Pierre-Auguste Renoir
1841–1919
Oil on canvas
71 × 92 cm
NG6478

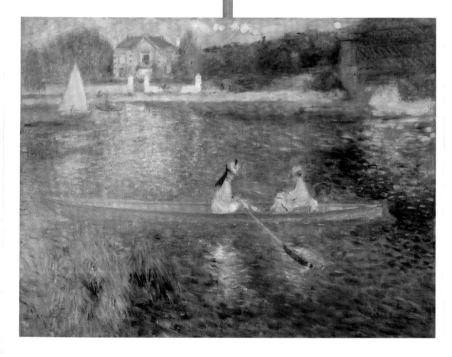

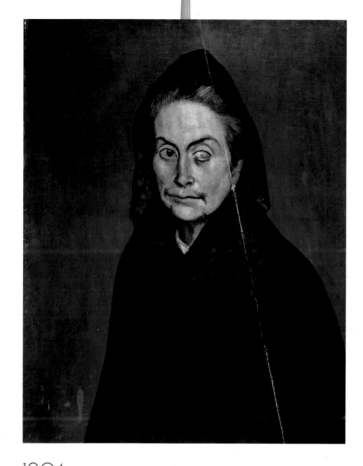

1904

La Celestina, 1904
Pablo Picasso, 1881–1973
Oil on canvas
74.5 × 58.5 cm
Held by the Musée Picasso, Paris

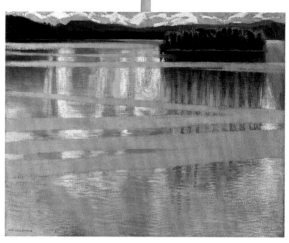

1905

Lake Keitele, 1905
Akseli Gallen-Kallela
1865–1931
Oil on canvas
53 × 66 cm
NG6574

1958

RE 19, 1958
Yves Klein
1865–1931
Sponge, stone and
pigments on wood
and canvas
145 × 116 cm
Held by Städel Museum

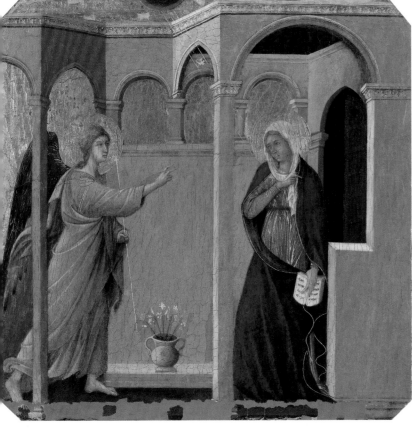

1307

The Annunciation, 1307/08–11
Duccio, active 1278, died 1319
Egg tempera on wood
44.5 × 45.8 cm
NG1139

1491

The Virgin of the Rocks
about 1491/92–99 and
1506–08
Leonardo da Vinci
1452–1519
Oil on poplar
189.5 × 120 cm
NG1093

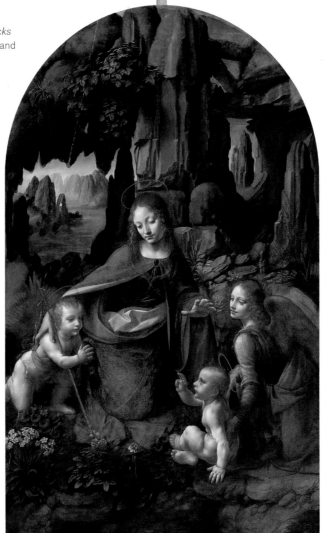

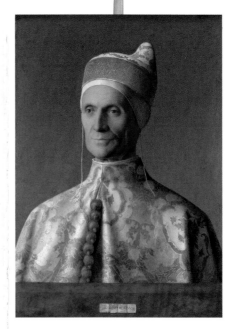

1501

Doge Leonardo Loredan, 1501–02
Giovanni Bellini, active about 1459;
died 1516
Oil on poplar
61.6 × 45.1 cm
NG189

1520

Bacchus and Ariadne
1520–23
Titian
active about 1506;
died 1576
Oil on canvas
176.5 × 191 cm
NG35

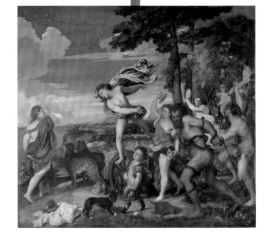

174○

A Regatta on the Grand Canal, about 1740
Canaletto, 1697–1768
Oil on canvas
122.1 × 182.8 cm
NG4454

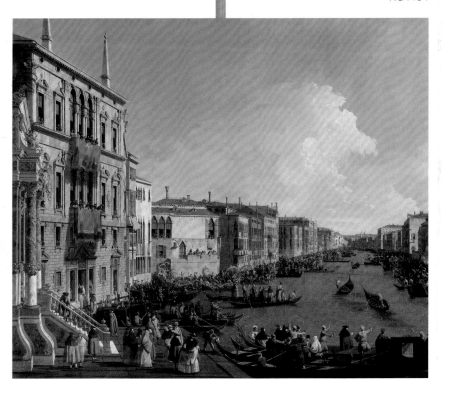

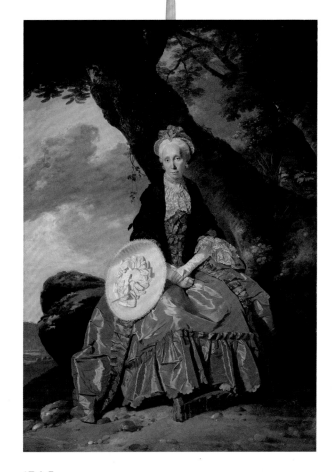

1763

Mrs Oswald, about 1763–64
Johann Zoffany, 1733?–1810
Oil on canvas
226.5 × 158.8 cm
NG4931

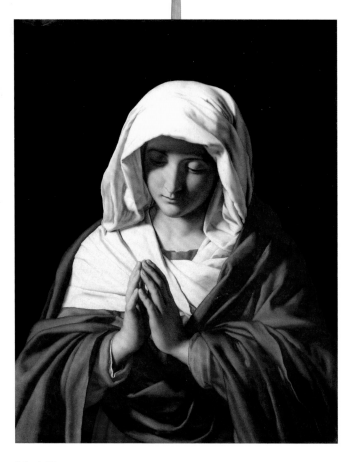

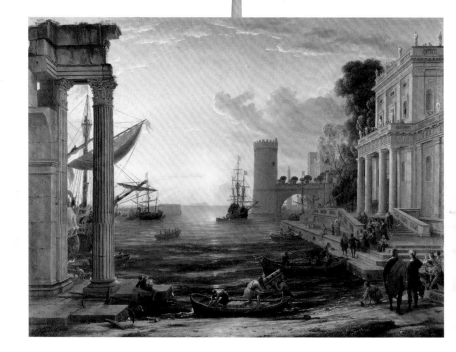

1648

Seaport with the Embarkation of the Queen of Sheba, 1648
Claude, 1604/05?–1682
Oil on canvas
149.1 × 196.7 cm
NG14

1640

The Virgin in Prayer, 1640–50
Sassoferrato, 1609–1685
Oil on canvas
73 × 57.7 cm
NG200

RED

Red is the oldest colour

Though its tones vary widely – from the earthy reds of animals depicted on cave walls to the blazing reds of modern abstraction – red is unmistakeably intense in its emotional register. We think of the flames of passion, the heat of anger and the flashing red of a warning sign. Red is the colour of flushed cheeks revealing embarrassment, fury, excitement or lust. Or we might think of it as a flavour of singular intensity: a rich red wine, a bloody red steak or a searingly hot red chilli pepper.

Many cultures have used red in ceremonial contexts, from Roman generals painting their bodies red after a military victory to red-robed Catholic cardinals, to the red dresses worn in traditional Chinese weddings. Its luxurious associations, partly due to the difficulty and expense of using red dye for clothing, is retained in the present art market: red paintings are said to sell better than any other. Above all, perhaps, red is the colour of blood, an indicator of mortality and death, but also of the lifeblood that sustains existence. Small wonder red has remained a constant throughout global history.

In paintings, while blue recedes, red advances. Blue seems distant and inaccessible, but red is always close and hot. In a painting, a moment of red, however small, will blaze out – a warning, a cry, an appeal, a temptation.

Saints Jerome
and John the Baptist

Masaccio
about 1428–9

Like many great rock stars, Masaccio died at the age of 27, leaving behind a small but revolutionary body of work. His paintings would transform Western art completely, as they were the first to fully embrace mathematical perspective – the illusion of three-dimensional space on a flat surface – which kept its place at the heart of European painting right up until the early twentieth century.

This painting is one fragment of a larger altarpiece, made for the church of Santa Maria Maggiore in Rome, which was cut up and dispersed in the seventeenth century. Seen as a complete object, the altarpiece would have dazzled in its colour and radical realism. In this fragment, we see two full-length saints, Saint Jerome and Saint John the Baptist. They're depicted in such a way as to be easily identified: Saint Jerome is shown carrying the Bible and a model of a Christian church, with a lion at his feet; Saint John, with his shaggy hair and beard, his camel-hair undershirt and bare feet, holds a spindly cross. Their brightly coloured clothing has a part to play too. Saint Jerome's crimson robe and wide-brimmed hat are symbols of his important role in Christianity as the translator of the Bible; Saint John's pink cloak sets off his grimy undergarment and emphasises his importance as the precursor of Christ. Where the painting becomes truly radical is in the fall of light on the saints' clothes. Their bright red and pink garments are both lit from the same place, giving their bodies volume and presence. Masaccio's revolution is laid bare. These saints seem to occupy space just as we do. The barrier between life and art has been broken down.

SEE ALSO
Duccio,
The Wilton
Diptych,
Holbein

1428

Portrait of a Man

Antonello da Messina

about 1475–6

No one is sure of this man's identity, although the intimacy of his look suggests it may be the artist himself. Judging by his plain outfit, he's certainly no authority figure, but whoever he is, there's no denying the command of that stare. The blaring red of his cap, subtly modelled to suggest two different sources of illumination, sets the tone of intense and forceful attention. That red returns in subdued echoes across the painting: as a pink accent on his cheeks and eyelids, at the edges of his tightly closed lips and in the crimson garment beneath his purple robe. The effect is of a smouldering, hot-blooded vitality.

The naturalistic effect of this painting is startling now and would have been doubly so when first seen. To achieve it, Antonello, a painter from Sicily, studied the new techniques that artists from northern Europe, especially present-day Belgium (then known as Flanders), were using. They applied layers of semi-transparent oil paint to make every colour richer and more luminous. The effect mimics the way we perceive light falling across skin and fabric. Antonello was quick to adopt this approach and he has been credited with introducing oil painting to Italy when he established himself in Venice around the time this painting was made. Upon seeing his work,

SEE ALSO
Bellini,
Moroni,
van Eyck

many artists abandoned the convention of using egg yolk and embraced oil as a radical new medium. Here Antonello showcases the reason for their enthusiasm: the realism of that stubbly chin, or those gentle eyelashes, would have been impossible to achieve with egg tempera. The naturalistic fading of light and shadow across the red cap, giving it a convincing sense of volume, is another feat of naturalism made possible by oil. This is portraiture coming to life: a living face with blood in its veins.

The Entombment

Michelangelo

about 1500–1

The list of what we don't know about this painting is long: who paid for it, where it was originally meant to be hung, and why some parts aren't finished – and that's just for starters. We are unsure even of the exact subject: it seems to depict a moment between the death and the burial of Jesus Christ, but it is unclear if we are seeing the body brought down from the cross (a Deposition) or brought into the tomb (an Entombment). The painting itself was probably commissioned for a church in Rome and abandoned by Michelangelo due to other, more significant projects – namely, his giant sculpture of David, made for the city of Florence around the same time. But even in unfinished works we see the artist's remarkable invention and virtuosity at work.

SEE ALSO
Leonardo,
Raphael

A painting that raises many, mostly unanswerable, questions is a tantalising challenge, with colour offering critical clues. Michelangelo uses colour not literally to convey the object he's depicting, but to turn up the emotional heat of the narrative. That blast of orangey-red in the robe of the figure on the left is warmed by the green of its inner lining. At the same time, the colour of the robe of the figure opposite – this time mostly green, with pink sleeves touched with red – gains strength through its relationship to that bright red on the left. Red and green are complementary colours, which reinforce each other when brought together. So on each side of the central figure – the dead body of Jesus Christ, recently lowered from the crucifix and on its way to the tomb in the top right corner – there is a strip of powerful colour, like open brackets on either side of a word. The result is a dynamic balancing force, and our eyes are drawn always back to Christ's body. Here colour is no mere decoration, but a means to emphasise the emotional force of the story.

Portrait of Pope Julius II

Raphael

1511

Rumour has it that when this painting was first shown in public, people shook in fear and ran away. Like many anecdotes about Renaissance art, this is probably an exaggeration at best. What's important is the existence of the story, which is a tribute to Raphael's astonishing and radically realistic treatment of the man who was arguably the most powerful person on the planet at the time. This is Pope Julius II, famous now for his patronage of artists such as Michelangelo and Raphael, but better known in his own time for his militant approach to his job. Popes were leaders of the Church and also rulers of an area of the Italian peninsula known as the Papal States. Expanding the territory of the latter, through dogged military means, was one of Julius's prime objectives. In Raphael's painting, both aspects of Julius's position come together. The pope is shown in his bright red fur-lined mantle, worn over a white silk surplice. The lush, saturated reds of the mantle both indicate the papacy's wealth and enable Raphael to showcase his command of the medium of oil paint. Wearing red had symbolic meaning too, recalling the blood of Jesus Christ and the Christian martyrs, and thereby indicating the elevated status of the pope within the Church hierarchy.

Julius's throne is covered in red velvet and topped with two golden acorns, a reference to his family name, della Rovere ('of the oak tree' in Italian). The crossed keys of Saint Peter, the symbol of the papacy, appear on the green wallpaper behind. So far, so conventional. But look at his hands: don't they seem like those of a much younger man? The left hand seems to grip the arm of the throne, as if unwilling to let go. And Julius's bristly beard – which to a modern audience may

seem to suggest wisdom – was actually grown as a political gesture. The city of Bologna had recently rebelled against the pope's rule, toppling a gigantic statue of him by Michelangelo in the process. Julius grew the beard as a symbol of mourning for the loss of the city, in reference to ancient traditions. That inward, rather melancholy expression might, then, invite less sympathy than we might initially grant it. And Raphael's placement of the viewer –

SEE ALSO Leonardo, Michelangelo, Moroni

at the pope's ear, in a position that no one but the highest-level member of the papal entourage would have taken in reality – lets us feel we can eavesdrop on his private conversations, even to imagine we can gain insight into his deepest thoughts. This is a radical break with the conventional presentation of popes in paintings, who were usually shown either kneeling in profile or face-on, as monarchs often were. The artist's naturalistic treatment of Julius's body – the pinks of his flushed cheeks brought out by the deep red of the mantle – makes this a breathing, brooding likeness. The optical vibration of the red against the green pushes Julius forward, giving him a commanding physical presence and making the painting throb with intense colour. X-ray examination of the painting has revealed that Raphael painted the powerful green over an earlier design in blue. It seems clear that the green was applied to lend greater force to the red, an effect it retains. Little wonder that the story of public panic has lasted as long as it has. There is something startling about being brought so close to someone almost thrumming with energy and power.

1511

Portrait of a Lady ('La Dama in Rosso')

Giovanni Battista Moroni

about 1556–60

The woman looks up as though she's been waiting for us, one hand on a fan. Her flushed cheeks and quizzical expression could suggest impatience or curiosity. Thanks to a restrained grey background – a speciality of Moroni's – our attention is focussed on her astonishing satin dress, which occupies a great swathe of the painting's surface. Its dominance makes perfect sense when you calculate the staggering cost of such a garment. The sitter must have been keen to display it as a reflection of her wealth and taste. This particular style was fashionable at the time and emphasised the opulence of the materials with which it was made: the shoulders have small slashes with white silk lining pulled through; the underlay skirt is of orange silk with real gold thread sewn in.

The dress has been dyed in cochineal, a pigment introduced to western Europe shortly before this painting was made, as a result of colonial expansion in the Americas. The cochineal is a small insect that lives on cacti. It produces carminic acid or carmine, a naturally bright red substance that can be used to dye cloth. This sitter's dress, then, was one of the most expensive items of clothing available

SEE ALSO
Antonello,
Holbein,
Van Dyck

at the time. Yet she's no mere clothes horse, showing off her latest purchase. Many think this is a portrait of Lucia Albani, a celebrated poet from the northern Italian city of Brescia. Albani was well regarded in her day and her works were widely read. That might account for the confidence with which she stares us down. The forceful colour relationships of red and gold – in her hair, skin, and dress – feel like extensions of a character that retains its command centuries later.

Samson and Delilah

Peter Paul Rubens
about 1609–10

Red accents across the whole of this painting give it its compelling heat. The intense, rich red of Delilah's silk dress seems to radiate warmth. Rubens's meticulous attention to its slippery surface is made that much more tactile by the presence of the semi-nude Samson, whose slumbering bulk makes contact with the dress; we can imagine how it feels against his naked skin. Rubens uses this call to the senses to explore the meaning of the biblical narrative. Delilah has betrayed Samson by seducing him into revealing the source of his enormous strength: his hair. After a night of lovemaking, Samson has fallen asleep and Delilah has allowed her accomplices to get to work. One cuts Samson's hair with infinite care while another holds a candle so the cutter can see what he's doing. Meanwhile, Philistine soldiers gather tentatively in the doorway, ready to arrest and imprison Samson. The theme of love and its pains is picked up in the statue of Venus and Cupid, the classical gods of love, in the niche above, but the focus is undoubtedly on the relationship between Delilah and her sleeping victim. Her relaxed posture, one hand placed lightly on his back, undress and gentle expression hint at the intimacy of the undercover agent who falls in love with her prey. The combination of sensuality, tenderness and betrayal is exquisitely rendered in the sequence of touches between them: note his right hand, resting babyishly on her belly, and his left, like a boxer's fist, now curling open uselessly.

SEE ALSO
Titian,
Van Dyck

This painting was commissioned to hang over the fireplace of Nicolaas Rockox, the alderman of Rubens's hometown, Antwerp. Imagine it illuminated by the dancing flames of the fire below, when the heat of the dress would take on a reddish glow, a tribute to the power of seduction to defeat even the mightiest of men.

Triple Portrait of Cardinal de Richelieu

Philippe de Champaigne

probably 1642

In the seventeenth century, it was common for an important individual to commission a self portrait in stone, bronze or paint. While a painter could bring their equipment to the sitter's location of choice without too much trouble, sculpture is a messy business, requiring long hours spent in a dusty studio, which would have been no place for a man such as Armand Jean du Plessis, Cardinal de Richelieu, chief minister of France. For a sculptural portrait, a painter would often therefore be commissioned to make portraits showing various views of the sitter's head and shoulders which a sculptor could then work from. This painting was made for exactly such a purpose: once completed, it was sent to the sculptor Francesco Mochi in Rome, who made a marble bust based on it. The painting contains no extraneous information, depicting the three views against a plain background. The painter Champaigne even inscribed a helpful note to Mochi on the painting itself: above the right-hand head is the text 'of these two profiles, this is the better one', suggesting that he'd captured a more faithful likeness from that angle.

SEE ALSO
Courbet,
Kalf,
Van Gogh,
Raphael

In the painting, Richelieu is depicted wearing traditional cardinal's garb: a red skullcap and a red cape with a high white collar. He also sports a blue silk ribbon with a gold Maltese cross dangling from it, showing that he was a member of the Order of the Holy Spirit, the highest order of chivalry under the Bourbon kings for whom he worked (incidentally, this is the origin of the phrase 'cordon bleu', which is applied to cookery of the highest order). The red of Richelieu's robe, used by cardinals to this day, symbolises the blood of Christ and

the Christian martyrs, thereby associating the wearer more closely with his faith and reflecting the cardinals' status as the closest advisors to the pope, who are often to be seen wearing red.

Champaigne's painting depicts the cardinal as the stern and intimidating figure he undoubtedly was. A hugely powerful and authoritarian figure from 1624, when he became the king's chief minister, to his death in 1642, the year in which this painting was made, Richelieu instigated important reforms in government to secure the might of the monarchy. Richelieu was also an important patron and art collector, who understood the role of the arts in communicating authority. He employed Champaigne as a portraitist, giving him the sole right to depict the cardinal in his full red regalia. Champaigne's precise and occasionally cold style provided Richelieu with the ideal medium to express his sense of himself. As the owner of the largest private collection of Roman and Greek sculpture in France, Richelieu was particularly interested in commissioning sculptural portraits of himself that had something of the grandeur of busts of ancient emperors. This portrait can be quite easily imagined as a marble bust, fusing a classicism with contemporary politics.

The sculpture, though, no longer exists. It was carved in marble by Mochi, using Champaigne's painting as a guide, and installed in one of the cardinal's palaces, the Château de la Meilleraye in Poitou, western France, where it sat for nearly 150 years. Then, in 1793, French revolutionaries broke off the cardinal's marble head to use as a counterweight on a spit on which meat was roasted. The head had reverted to a mere lump of stone again.

The Toilet of Venus

Diego Velázquez

1647–51

We confidently call this reclining woman Venus, but little in the painting backs up the claim. The presence of the winged child, Venus' son Cupid, and the mirror, with which the classical goddess of love and beauty is sometimes depicted as a symbol of vanity, are the only hard evidence. 'Venus' has always been a convenient name to give a nude woman in a painting, as a means of justifying suggestive content. The classical allusion both lends the work an air of intellectual integrity and acts as an excuse for her nudity, since gods and goddesses in ancient sculpture were always depicted partially or entirely nude. No modern viewer could be fooled by the title, though: this is a naked woman, painted in such a way as to emphasise the graceful curves of her body.

The painting's composition frames the reclining woman, all the soft curves of the drapery echoing the shapes she creates with her pose, and the rich colour scheme acts as a counterpoint to the delicate pallor of her skin, from the deep red of the curtain hanging behind Cupid, which draws out the red accents in her flesh, to the creamy white sheet that picks out the swoop of her hip. The drape that hangs beneath her, whose curve echoes the shape of her pose, was originally mauve and has faded to grey. The warm tones of her lower back catch the reflected reddish colour of this swathe of fabric. All the subtle touches add up to much more than the idealised, beautiful but remote goddess of classical painting and sculpture: this is a portrait of a living woman whose rosy cheeks speak of the red blood in her veins.

The sensuality of the painting is everywhere apparent, perhaps especially in Velázquez's hazy brushwork, which lends the painting a heady atmosphere, like a dream or memory. Even the reflection in the mirror is indistinct, as though fogged up by breath. At this late stage

in his career, Velázquez combined diluted paint with thicker, more opaque marks, mimicking the human eye's focal and peripheral vision. By contrasting loaded strokes of dark paint with the indistinct contours of Venus' body, Velazquez plays a game with the viewer's perception. The deliberate imprecision of her body, and the minimal description of her face, allows the spectator to complete the image for themselves. This playful effect is intended to carry an erotic charge for the male patron who commissioned it. Laid out for the pleasure of the male viewer, does Venus watch us watching her, revelling perhaps in the complex game of perception played out in the painting? Or is she admiring herself instead, completely unashamed in her nudity, rather she takes pleasure from it – and if she is aware of being seen, then enjoying it all the more.

SEE ALSO
Titian,
Niccolò,
Rubens

1647

What's remarkable about this painting is that it's the only surviving example of a nude by Velázquez, who was the court painter to Philip IV, the king of Spain. During his time, in which the Catholic Church exerted its authority through the Inquisition and paid close attention to the content of artworks, the female nude was largely forbidden territory for Spanish artists. This is a painting that could not have been shown in public during the artist's lifetime, and was certainly made to hang in an inner chamber in a palace, far from the prying eyes of the authorities. It seems likely that the painting was commissioned by the Marqués del Carpio, the son of the First Minister of Spain. Its popular title, 'The Rokeby Venus', derives from its eventual presence in Rokeby Park, County Durham, as part of the collection of the politician John Morritt, before it was acquired by London's National Gallery in 1906.

Still Life with Drinking-Horn

Willem Kalf
about 1653

Almost every object in this still life, painted in Amsterdam by Willem Kalf, has come from somewhere else. The bunched carpet on the right is an expensive import from Persia, the titular buffalo horn has been brought in from North America, the glass decanter from Venice and the lemon from Italy or Spain. The bright red lobster, whose reflection can be seen in many of the surfaces that surround it, was a delicacy that indicated great wealth and hints at a feast or celebration soon to take place. The entire painting is suggestive of this kind of material excess and gluttonous conviviality: the horn would be filled with wine and passed around; the lemon squeezed over the lobster; the pie, just visible behind the lobster, would be cut open and shared. The event might have been the annual feast of the men who paid for the painting, members of the Amsterdam archers' guild, who would have hung it in their guildhall as a reminder of their own worldly successes. Their patron was the early Christian martyr Saint Sebastian, who can be seen, cast in silver, pierced with arrows and flanked by Roman guards, as the support for the drinking horn. Because of the far-flung origins of the objects depicted, the painting acts as a sort of map, suggesting trading relationships in Kalf's city, which at the time was one of the richest and most powerful in the world. The liveliness of the painting – the way the lobster, clearly already cooked, seems to clamber down towards the lemon, which almost topples off the table – is a way of bringing animation to the conventionally static composition of a still life. Everything seems poised to move.

SEE ALSO
Cuyp,
Bosschaert,
Van Gogh

Combing the Hair

Hilaire-Germain-Edgar Degas
about 1896

How much can one colour do? In the case of this painting by Degas, just about anything. A single blazing red, darkened or lightened, is made to stand for curtain and wall, hair and skin, dress and picture frame, shadow and light. Because Degas never sold this painting, keeping it in his possession until his death, it might be tempting to think of it as an experiment in colour, a kind of personal test. But that would be to miss the strange emotional tension at its heart, and red's role within it. A young woman, who is visibly pregnant, is having her hair combed by a standing older woman. As the comb is dragged through the younger woman's hair, she instinctively reaches back to hold onto her scalp; her other hand seems to twitch in pain. Her face is flushed and her nostrils flare in alarm. The standing woman is so indifferent to this response that it's hard not to see a streak of cruelty in her actions, as she indifferently tugs the comb through the mass of bright red hair. Very little of the rest of the scene is described, and when it is, the description is cursory at best: a heavy curtain at a window, a hairbrush, bottle of perfume and perhaps discarded jewellery on the table at the front. For Degas, the interest is in the language of the human body, the way it can be eloquent without recourse to speech.

SEE ALSO
Monet,
Renoir,
Rubens

That burning red seems to act as a parallel to the psychological drama of the two women's relationship: the idea of using colour for its own expressive sake teeters on abstraction. Not surprising, then, that after Degas died, the painting was bought by Henri Matisse, an artist whose intensely coloured, powerfully expressive paintings would represent another step towards the total abstraction of twentieth-century painting.

1896

Red Square

Kazimir Malevich

1915

The politics of early twentieth-century Russia suffuse this radically reductive painting. Though painted two years before the onset of the revolution that would transform Russia, this painting is the artistic equivalent of the utopian ideals that underpinned it. Originally titled *Painterly Realism of a Peasant Woman in Two Dimensions*, the deadpan joke of this title underscores its extreme novelty: many Russian paintings, made before this and since, depict peasant women in sentimental portrayals of rural life. Malevich himself underwent traditional art training in Moscow and painted works on that theme. By 1915, however, he realised that naturalistic painting no longer communicated the ideals he sought in art. Freedom from conventional subject matter stood for the liberation promised by revolutionary politics. Instead of figures arranged in geometric compositions, pure geometry. Instead of colour representing bodies, objects and spaces, pure colour. The rich, dense red of the central shape is enhanced in the literal density of the paint itself. What's missing from reproductions of works by Malevich is the heavily worked surface, which gives the paintings a physical presence that is almost sculptural. The red shape leaps forward, away from the pale background, in a celebratory, energetic way.

SEE ALSO
Rothko,
Klein,
Cuyp

This painting is about as reduced as possible for a painting made in 1915. Because of this, Malevich considered this work, and others like it, to be almost the endpoint of painting. It was a new visual language for a new political reality. For Malevich, the liberation offered by such drastic reductions of the language of paint was exhilarating. The term he used for such an art was Suprematism, a movement in which colour would have independence in order to, as he put it, 'free

art from the dead weight of the real world.' The term comes from the Latin word *supremus*, meaning 'the highest' or 'the supreme', indicating Malevich's intention to lift painting beyond mere reflection of the visual world, towards a more fundamental expression of human feeling. Using basic geometric forms and unmixed, often primary colours, Suprematist artists, including El Lissitzky, Liubov Popova and Olga Rozanova, made abstractions that spoke directly to the viewer, evoking pure sensations and experiences in the most immediate way possible. Suprematism also paralleled political transformations taking place at the time. Malevich was deeply optimistic about the outcomes of the Bolshevik Revolution that would take place two years after this painting was made, and hoped that Suprematism might become the official style of the new political order. For a short time he was employed by the new government as an educator, teaching in art schools in Vitebsk and St Petersburg. The Suprematist style found its way into architecture, theatre and even ceramics, but under Stalin the movement was suppressed in favour of a return to propagandistic realistic painting – with peasant women again a popular subject.

This painting was first shown in a group exhibition in December 1915 in St Petersburg, entitled *The Last Exhibition of Futurist Painting 0.10*, which was the official public launch of the Suprematist movement. Malevich showed 39 paintings, and hung this piece's counterpart, the *Black Square*, in the top corner of the room known in Russia as the 'red corner', a place where the religious icon would be hung in a Russian household. The flatness and abstraction of Russian icons were important early influences on Malevich, and this painting could be seen as a modern, secular, politically charged variant on religious painting: a new icon for a new age.

No. 46

Mark Rothko

1957

Over two and a half metres tall and two metres wide, Mark Rothko's vast painting envelops the viewer in its fields of pulsing colour. Where they are shown in museums, Rothko's paintings usually hang without a frame and not behind protective glass, allowing the experience to absorb the viewer without distraction or mediation. For the artist, abstract painting was the means by which he could express what he believed were the fundamentals of human experience: 'tragedy, ecstasy, doom'. Such themes were not new to the history of western art, but before Rothko emerged in New York in the 1940s, they were an unusual subject for abstract painting. Rothko was a central figure in Abstract Expressionism, along with Jackson Pollock, Barnett Newman and Willem de Kooning, among others. Their large-scale, dramatic and expressive version of abstract painting helped the balance of artistic influence shift from Paris to New York immediately after the Second World War.

SEE ALSO
Cuyp,
Bosschaert,
Van Gogh

In this painting, the colour red is explored and revealed with differing intensity and qualities in three characteristic horizontal bands: a blazing pure red in the top, and, more subtly soaking through, the pale ochre and black layers beneath. Despite the compositional simplicity of this work, the way it was made is not entirely obvious. Rothko was fond of thinning his oil paint with turpentine and applying it to the canvas so it stained into the surface. Subsequent layers of colour were added in veil-like washes of paint, so that colour only gradually reveals itself after long and slow observation. Encouraging a meditative response, Rothko's painting acts on us over time, like an unfolding piece of music, and speaks directly to us in the simple and emotive language of colour.

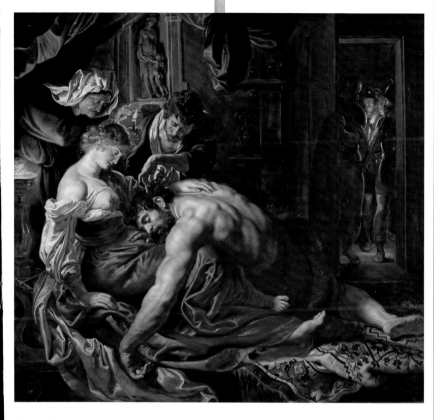

1609

Samson and Delilah, about 1609–10
Peter Paul Rubens, 1577–1640
Oil on wood, 185 x 205 cm
NG6461

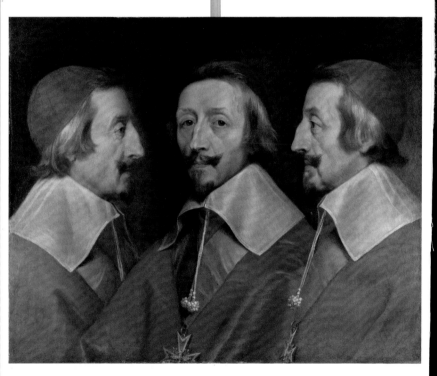

1642

Triple Portrait of Cardinal de Richelieu, probably 1642
Philippe de Champaigne and studio, 1602–1674
Oil on canvas, 58.7 x 72.8 cm
NG798

1915

*Red Square (Painterly Realism of a
Peasant Woman in Two Dimensions)*, 1915
Kazimir Malevich, 1878–1935
Oil on canvas, 53 x 53 cm
Russian Museum, Saint Petersburg

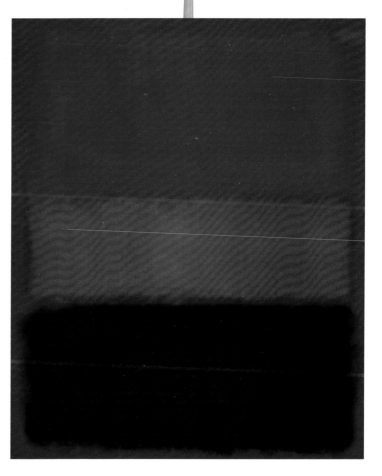

1957

No. 46 (Black, Ochre, Red over Red), 1957
Mark Rothko, 1903–1970
Oil on canvas, 252.7 x 207 cm
Museum of Contemporary Art (MOCA), Los Angeles

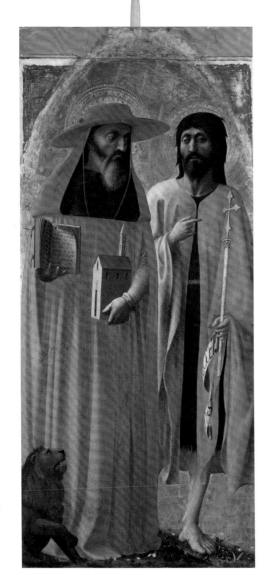

1428

*Saints Jerome
and John the
Baptist*
about 1428–29
Masaccio,
1401–1428/9?
Egg tempera on
poplar, 125 x
58.9 cm
NG5962

1475

Portrait of a Man, about 1475–76
Antonello da Messina,
active 1456; died 1479
Oil on poplar, 35.6 x 25.4 cm
NG1141

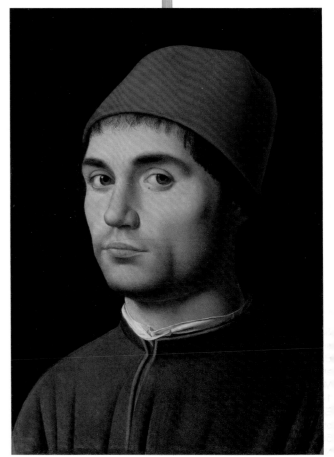

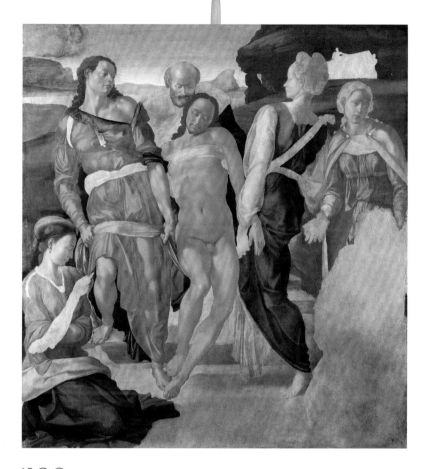

1500

The Entombment, about 1500–01
Michelangelo, 1475–1564
Oil on wood, 161.7 x 149.9 cm
NG790

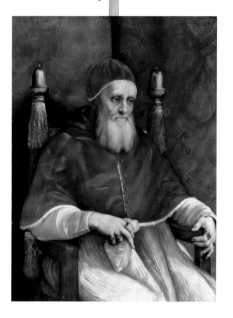

1511

Portrait of Pope Julius II, 1511
Raphael, 1483–1520
Oil on poplar, 108.7 x 81 cm
NG27

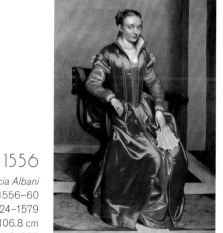

1556

*Portrait of a Lady, perhaps Contessa Lucia Albani
Avogadro ('La Dama in Rosso')*, about 1556–60
Giovanni Battista Moroni, 1520/24–1579
Oil on canvas, 155 x 106.8 cm
NG1023

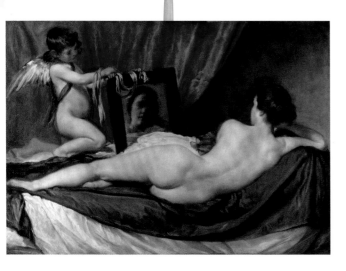

1647

The Toilet of Venus ('The Rokeby Venus'), 1647–51
Diego Velázquez, 1599–1660
Oil on canvas, 122.5 x 177 cm
NG2057

1653

*Still Life with the Drinking-Horn
of the Saint Sebastian Archers'
Guild, Lobster and Glasses*,
about 1653
Willem Kalf, 1619–1693
Oil on canvas, 86.4 x 102.2 cm
NG6444

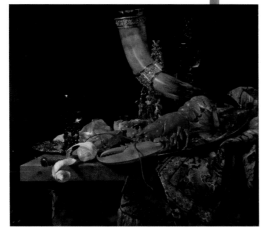

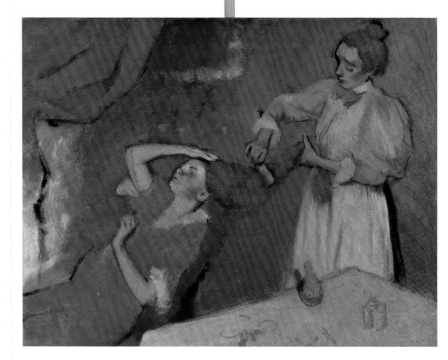

1896

Combing the Hair ('La Coiffure'), about 1896
Hilaire-Germain-Edgar Degas, 1834–1917
Oil on canvas, 114.3 x 146.7 cm
NG4865

GREEN

Green is the slipperiest of colours

On the one hand, it is associated with new life: the leaves of springtime representing regeneration and renewal. On the other, it has strikingly opposite, evil and unappealing associations. It can suggest sickliness and symbolise jealousy; it can allude to poison or be poisonous itself (arsenic was often used in green paint, a toxic ingredient that led to serious illness). This continual shifting is part of its properties as a colour, too. The first green pigments, used in Neolithic times, used organic materials, probably vegetable in origin, that faded fast. Later, from ancient Egypt to Rome, green minerals (celadonite and glauconite), malachite or copper acetates were used, but these tended to change colour over time. Little wonder that green came to be associated with treachery and chance, from Judas, often shown in green, to the green baize of the gambling table.

Though easily made by blending yellow and blue, green was initially used as a pure pigment in its own right, but even then its qualities could vary widely. Green can be mixed in any number of ways for different effects: with more yellow, it is warmer; with more blue, it is cooler. However, because of this, it can be difficult to replicate. If green is anything, it is infinitely variable, and this range of possibilities has made it endlessly appealing to artists over the centuries.

Portrait of Giovanni(?) Arnolfini and his Wife

Jan van Eyck

1434

Jan van Eyck was commissioned to paint this portrait of the Italian merchant Giovanni di Nicolao Arnolfini and his wife, Costanza Trenta, who were living in Bruges. The viewer's attention is immediately drawn to Costanza's green dress, a deliberate effect on the part of the artist. By surrounding that expanse of deep green with vivid, complementary red, van Eyck intensifies both colours and emphasises the theme of luxury within the painting – the couple's wealth being pointed to by almost every detail of the painting. That fur-lined dress would have been hugely expensive, in part due to the complexity of the processes needed to successfully dye fabric green, meaning that the colour was available only to the well-off. And there's a fantastic abundance of it, so much that the woman has to gather up swathes to prevent it from cascading over the floor in front of her. In doing so, she gives the appearance of being pregnant, a reading reinforced by the position of her left hand.

SEE ALSO
Antonello,
Bellini,
Holbein

In fact, it's generally believed that she is not meant to be literally pregnant, but it was fashionable in this period for married women to be portrayed as being so, and van Eyck was known for depicting women's bodies in this way. Furthering the family line was, after all, the principal function of marriage at this time, and that expanse of green can't help but remind us of the traditional symbolism of the colour: the green shoots of new life, while the red bed she stands beside also has its obvious implications. However, the couple were not to be so blessed: Costanza died without children in 1433, the year before this painting was completed.

Saint George
and the Dragon

Paolo Uccello

about 1470

While film-makers have the luxury of exploring every aspect of a narrative and its characters, painters telling stories have a very different task. Compression is key. Here the Florentine Renaissance artist Uccello chooses two moments from the same story, depicting them in a single space. On the right, the early Christian saint George sinks his lance into the left nostril of a howling dragon, which bleeds tidily onto the ground. On the left – a scene that, in the actual story, comes slightly later – the princess, whose plight has led George to attack the dragon, holds a lead that is tied around the dragon's neck. The monster's lair, a craggy cave with a gloomy lake within, forms a kind of bracket that separates the second part of the narrative from the first. Using her pale blue belt as a lasso, the princess, dressed in fashionable Florentine garb, with a dainty tiara identifying her regality, will lead the weakened dragon to the city it has been tormenting, where it will be publicly beheaded – leading to mass conversions to Christianity. The tornado-like swirl of cloud in the sky above George, which seems positioned to lend strength to the thrust of his lance, is an indication of the saint's divine support and a reminder of the Christian origin of the story.

SEE ALSO
Bermejo,
Masaccio,
Titian

Uccello has based his painting on the life of Saint George as told in the *Golden Legend*, a compendium of stories about saints put together in the thirteenth century and an important source for artists. However, the narrative was not Uccello's foremost concern. His principal interest was exploring linear perspective, then a relatively new idea in painting, which allowed painters to create the illusion of

depth by using parallel lines that seem to meet at a distant vanishing point. The dark green vegetation on the stony ground, with leaves and stems carefully picked out in a lighter green, is laid out in irregular geometric patterns for that very purpose. This evokes a grid-like underlying structure, laid flat, which draws our eye deep into the painting's space to the light blue mountains at the horizon. Though somewhat naive to modern eyes, Uccello's use of illusionistic space is a radical move away from the impregnable gold backgrounds used in Italian painting up to that point.

Our attention is drawn, more than anything, to the dragon itself. It is a bizarre amalgam of different creatures, having the wings of a bat, the teeth of a snake, the tail of a lizard and the markings of a butterfly. Uccello's use of colour is considered and significant. The blazing green emphasises the creature's reptilian qualities, while yellow highlights create a convincing impression of a physical presence by seeming to light the dragon's body from the left-hand side. The green of the evil dragon also marks it out from the 'good' characters standing to either side, both wearing shades of red: the bright red of George's saddle and the reddish pinks of the princess's robe and pointy shoes. These vivid complementary colours intensify the bright green of the monster, and as compositional devices, they help place the main characters in the foreground of the scene, against the milder receding colours of the background. It is the dragon's transformation from ferocious to impotent that is the pivotal event, and the red blood dripping from its mouth marks this narrative point by linking the two sides of the story.

The Ambassadors

Hans Holbein the Younger

1533

A green damask silk curtain provides a theatrical backdrop to this stately double portrait, focusing our attention on the two ambassadors and the shelves laden with objects that divide them. Complementary reds and pinks intensify the green by contrast, from the dazzling pink satin sleeves to the expensive red Turkish carpet draped over the top shelf. Holbein was revered in his time not only for his ability to capture facial likeness, but also for his mastery of the depiction of luxurious fabrics such as these. The highly decorated curtain would have been built up in several layers of opaque oil paint to give it its rich, almost luminous intensity.

The two Frenchmen depicted in the portrait, Jean de Dinteville and Georges de Selve, posed for the painting in London, where de Dinteville was French ambassador to the court of Henry VIII. Jean de Dinteville commissioned Henry's German court artist, Holbein, to commemorate the visit of de Selve, the bishop of Lavaur and later ambassador to the Republic of Venice. Religious uncertainty was rife at this time in England, while German clerics, led by Martin Luther, were calling for reform of the Catholic Church and the fault lines were spreading across Europe. Only a year after this painting was made, Henry would break decisively with Rome, becoming head of an independent Church of England. The two figures in this painting were both committed to ensuring that this split did not happen. This painting tells of their concern and determination, not through the men themselves, but the objects that – unusually for a portrait – occupy the centre stage.

There is a plethora of symbolic detail to note and decipher in this painting, beginning with the shelving unit, divided into a lower and upper level. On each shelf there is a globe: the lower offers a

conventional map of the earth and the upper, a map of the stars. This division, speaking of the physical and the spiritual, of the visible and invisible, is echoed in the men themselves, whose poses imply action (de Dinteville) and reflection (de Selve). On the lower 'earthly' shelf, a red maths book, showing division sums, is held open with a set square.

SEE ALSO
Bellini,
van Eyck,
Gainsborough

The upended globe beside it embodies the world being turned upside down. The instruments here cannot be played: the lute has a broken string and the set of pipes in their leather case is missing a pipe. Disharmony reigns. Above, on the carpeted shelf, are objects that allude to navigation and timekeeping: complex sundials and quadrants, used mostly in shipping. The celestial globe, showing the stars in their constellations, suggests that a clear path to the future, away from choppy waters, is being sought. Yet despite this theological disquiet, both men are aware of the ephemerality of all things.

At the bottom of the painting is an object lit from a different angle to everything else: it's a human skull, visible only at a particular angle, which Holbein would have first drawn using a curved mirror. Death is ever-present, though on a different plane. The curtain also, itself taking up a distractingly large portion of the picture plane, almost casually reveals a crucial element of the painting. At the top left, it is slightly pulled back to reveal a carved crucifix, one of the only overtly Christian symbols in a painting full of allusions to the theological crisis of the time. There is a sense of something being hidden from us: the curtain in deceptive green is both an extravagant showcase of the wealth of the sitters and a means of concealing things we cannot be privy to.

The Death of Eurydice

Niccolò dell'Abate

about 1552–71

As we encounter this painting, our eye travels across huge imaginary distances, from the groups of figures in the foreground, through the clumps of vegetation in the centre that sway in the wind, the classical buildings and expanses of water, and finally to the mountain range beneath a turbulent sky. The various greens of the different parts of the painting gradually change according to their distance from the viewer. We move from the deep greens of the lower third of the painting, darkened with touches of brown and dark blue, into a paler green with hints of yellow and grey, which establishes the middle ground. As we reach the limits of our vision, the colour fades into smoky emeralds, pale greys and icy blues. This is atmospheric, or aerial, perspective, a means of portraying depth through tonal variation, which had characterised Leonardo da Vinci's landscape backgrounds from the early years of the same century. Niccolò's epic vision of the natural world is known as a 'world landscape': a macrocosmic panoramic view dwarfing the figures within it. World landscapes were made at a time before landscape painting emerged as a genre in its own right, and so pictures were still required to tell stories, no matter how small compared to the scale of the landscape in which they took place.

SEE ALSO
Bronzino,
Michelangelo,
Poussin

It's easy to overlook the narrative in this painting, which tells the first part of the classical mythological story of Eurydice, the nymph whose husband, Orpheus, makes a doomed attempt to rescue her from the underworld. In the middle distance, we see Orpheus, the legendary musician, charming the animals of the forest with his lute playing. He's oblivious to the fate of his wife in the painting's foreground, but we see it, thanks to the gesture of a beautiful nymph. Eurydice,

wearing a cascading turquoise robe, is running from the attentions of the shepherd and beekeeper Aristaeus, who is in a revealing pink robe. As she runs, Eurydice's left ankle is bitten by a poisonous snake and she dies; she appears again just to the right, stretched out on the ground, her robe beneath her. The presence of the sea god Proteus, depicted leaning on a gushing vessel on the far right, alludes to Aristaeus' actions after the tragedy. Finding all of his bees dead, he turns to Proteus for advice, who in turn informs him that it is a punishment for his hand in the death of Eurydice. For Niccolò, the clarity of the narrative is less important than the interplay between the breathtaking vista and the sinuous semi-clad figures; if not for the narrative, this could well be an open-air party, with characters dancing, relaxing or sleeping.

The Death of Eurydice is an example of the School of Fontainebleau, a style in painting, sculpture and decorative arts that developed in the French château of the same name under the patronage of King Francis I. Francis lured Italian artists and craftsmen to France to transform the château from a neglected hunting lodge into the opulent royal residence we know today. Niccolò moved from his native Modena, northern Italy, mainly to provide fresco decorations for the walls of the palace. He also made independent paintings on canvas, such as this one, in which mythological narratives were set within fantastical, dramatic settings. The elongated, even distorted bodies of the figures in this painting are characteristic of the Fontainebleau style, in which anatomical and geographical realism are sacrificed in favour of a decorative and elegant overall effect. Its original viewers were likely more captivated by the lush green expanse of landscape than the rather complex narrative it purports to depict.

Still Life of Flowers in a Wan-Li Vase

Ambrosius Bosschaert the Elder

1619

A bouquet of flowers springs up out of a small vase. Up close, each petal and leaf astonishes the viewer with its naturalism. Ambrosius Bosschaert specialised in painstakingly detailed images of floral arrangements like this, which proved hugely successful. The appeal of such paintings might seem obvious, yet there is more than meets the eye in such an ostensibly simple composition.

Two streaked tulips at the apex of the jumbled bouquet are representatives of the most sought-after flowers at that time, and were the subject of wild financial speculation, known as tulip mania, soon after this painting was made. The vase, another import, was brought into the northern Netherlands (then known as the United Provinces) by the Dutch East India Company, which brought tea, spices and porcelain objects back to Europe. With its gilt rim, the vase is another indication of the wealth of the artist's homeland.

SEE ALSO
Kalf,
Van Gogh,
Cuyp

It may seem unusual, amid all this conspicuous luxury, to include a nod to human mortality, but an awareness of life's fleeting nature was central to religious teaching in this period, and symbolic reminders of the shortness of life, such as hourglasses, skulls or smoking candles, were common in still-life paintings. Here, the healthy red petals of the tulips, bright against the complementary green of the surrounding leaves and the dark background, are contrasted with a conspicuously drooping flower, soon to shed its petals. Green bulbs meanwhile await their turn to bloom. Bosschaert indicates the cyclical nature of all existence through metaphor, turning an ordinary-looking bouquet into a mirror of life itself.

The Scale of Love

Jean-Antoine Watteau

1715–18

In a lush green glade, a couple make beautiful music together. The euphemism is appropriate: for Watteau, as for many artists before him and since, music and love are deeply intertwined. The textures of their clothing are finely rendered – the shimmering orange-pink silk of her dress; his shiny stockings and floppy red velvet beret – and indicate their social standing. These are upper-middle-class people luxuriating in idle flirtation and indolence.

Scenes such as this one were a revelation when first shown in public. Rather than depicting classical or Christian narratives, or morality lessons from literature, they celebrated aimless leisure and sensual abandon. The term used at the time to describe such novel compositions was *fête galante*. But it's the atmosphere, rather than the content, that makes paintings such as Watteau's so captivating. The trees that frame the couple seem hazy and insubstantial, like clouds of smoke. Rendered in tiny patches of a range of greens, the leaves enfold the figures as though in a protective mist, and act to underscore the intimacy of their exchange. The deep red of the male figure's hat has a powerful clarity, thanks to the complementary effect of the various greens that surround it. The bright reds of the woman's hairband and the bow at her breast are similarly enhanced in response to the rich green environment. Though romantic, even erotic in tone, the painting has a wistful atmosphere, expressed by the wispy, fading greens of the vegetation. All this flirtation and relaxation can't last. Watteau's painting acknowledges that pleasure is fleeting. Perhaps this couple does too, for there seems to be something distracted, even melancholy, in their faces.

1715

SEE ALSO
Claude,
Fragonard,
Zoffany,
Gainsborough

Mr and Mrs Andrews

Thomas Gainsborough

about 1750

Perhaps this painting's title is a bit misleading. After all, the recently married couple who commissioned this portrait, Robert Andrews and his new wife, Frances Carter, don't seem to be the main focus. Instead, they are shown to one side to allow us to take in the archetypal English rolling landscape: green hills, fields of arable land and livestock, and the distant spire of a country church. Gainsborough's love of nature is evident in the detail of the landscape: the textures of sheaves of wheat, stalks of grass and the cracked bark of an English oak tree are showcased to full effect.

It's possible that Mr and Mrs Andrews requested such an unusual composition. The countryside we see stretching out beyond the flamboyant green bench on which Frances sits was all part of the Andrews estate. Robert's gesture, with one hand in his pocket and his tricorne hat at a jaunty angle, his gun tucked under an arm, suggests the self-confidence of the man who has it all. His wife sits demurely beside him in a blue silk dress and pink heels that are clearly not designed for the muddy conditions.

On the other hand, Gainsborough might have been taking advantage of his familiarity with the subject (he and Andrews were old schoolmates) to indulge his love for landscape painting. If today

SEE ALSO
van Eyck,
Holbein,
Watteau

he is best known for his portrait paintings, it is because there was more demand for such and it was a more profitable genre. At the same time, there are several details in this painting – such as the pair of donkeys just in view – which may be a symbolic swipe at his subjects and their marriage. Considered alongside the perplexing absence in the lap of Mrs Andrews, where the canvas is left bare, this seemingly straightforward painting is replete with mystery.

Winter Landscape

Caspar David Friedrich

probably 1811

Small paintings can easily have the force of much larger ones. The work of the German Romantic painter Caspar David Friedrich is a case in point. Here he generates a sense of enormous scale through the extreme contrast of near and far. In the foreground are two crutches, abandoned in a snowdrift. Their owner, a man in a blue jacket, has apparently cast them aside to pray at a crucifix that stands among a small group of pine trees. Against the pale background flecked with tiny blue and purple strokes, the dark green of the trees is striking and powerfully moving. The trunk and branches of the pines echo the forms of the crucifix and the huge Gothic church visible as a cluster of spires in the distance. In this way, Friedrich is making the connection between the spiritual and the natural worlds visible as a rhyme within the painting. The somewhat limited palette lends the painting an air of gravity and solemnity.

SEE ALSO
Claude,
Poussin,
Gallen-Kallela

Like other Romantic painters, both in Germany and abroad, Friedrich sought to express a natural mysticism found in the landscape of his homeland. Friedrich had little interest in a documentary account of the natural world, instead evoking the emotional and subjectively experiential effect of nature. The bleak, unforgiving winter landscape is in this way a parallel of the man's spiritual isolation, suddenly redeemed through the apparition of the trees. The evergreen pines, strongly delineated against the hazy setting, imply the eternal and unchanging nature of Christian faith. Perhaps the distant church, so insubstantial in the painting, is a kind of vision: the man, healed through contact with the divine, suddenly sees his recovery reflected in concrete form. There's nothing modest about the impact of this painting, despite its scale.

The Cornfield

John Constable

1826

John Constable's paintings of the English landscape attempted to capture the freshness and vitality of the experience of actually being there. Unlike his contemporary, J. M. W. Turner, with whom he was and still is often compared, Constable eschewed classical or historical storytelling in favour of subjects that were of much greater personal significance. The limited geographical scope of Constable's paintings – he mostly depicted rural scenes of his home county, Suffolk – made his work unpopular, even controversial, in his day, due to its ordinary and perhaps mundane subject matter. Yet the apparently narrow focus of his work allowed Constable to explore his interest in the sensory experience of landscape.

In this painting, natural things are rendered with the intention to capture their texture rather than their likeness. The roughness of areas like the muddy path at the front right of the painting would have seemed too coarse for most of his contemporaries' taste. Landscape painting in Constable's time generally provided a setting for stories from classical mythology or military history. Even landscapes of real places – Rome and Venice were particularly popular – were seen to embody noble ideals. Constable's gritty vision of an ordinary British setting is far from the accepted standards of his day. And yet the painting is deeply evocative of the reality of the natural world. The earth seems genuinely grainy, the grass soft and tufted, the bark of the trees seemingly rough to the touch. Constable wanted a finished work like this one to have all the spontaneity of the sketches he made while sitting in the field itself. Bringing the sketches back to his studio in north London, he carefully worked them up into a composition that was both true to the touch and feel of the landscape and formally composed, as paintings in the past had been.

Like Turner, Constable used emerald green in his paintings, a new synthetic colour that was more stable than older alternatives such as verdigris – although, containing arsenic, it was no less toxic. The vibrant greens of the grass in the middle distance reflect Constable's enjoyment of this intense, bright pigment most clearly. The sparkling freshness of the scene, emphasised by the dabs of white highlight, proved unpalatable to many English critics of his time – though such an approach had a significant impact on young French painters such as Eugène Delacroix, who saw his work when on display in Paris. His legacy is visible in later French art too, such as many of the Impressionists' works.

The tall green screen of trees on the left-hand side is echoed by a slightly smaller group on the right, and then by another solitary tree deep in the centre. Our eye is gradually led from tree to tree into the deep space of the painting, with touches of paler greens added gradually to convincingly suggest distance. This elegant composition of elements is evidence of Constable's awareness of the landscape painters of the past, who structured their landscapes using a similar rhythm of shapes. The red of the little boy's waistcoat, placed amid the yellow-greens of the riverbank and the blue-greens of the water, is intensified through contrast, drawing our attention. He could be a substitute for the young Constable himself, face down in the bubbling stream as he quenches his thirst on a hot day. For Constable, nature was a complete sensory experience: the work is both a landscape and, in a sense, a soundscape. Constable is reconstructing the totality of that country lane – we can touch and hear it, in fact we can almost smell it.

SEE ALSO
Claude,
Poussin,
Turner

1826

Surprised!

Henri Rousseau

1891

SEE ALSO,
Poussin,
Van Gogh,
Uccello

Would you be surprised to know that the artist had never actually seen a tiger? Or even visited a jungle? Perhaps not, given the painting's somewhat naive style, with its strangely flat and simplified pattern of leaves and branches. Rousseau's fantastical paintings, often depicting exotic, mysterious settings, were all conceived and made in his home city of Paris; he never went anywhere else. He would visit the city's Jardin des Plantes, the botanical gardens, then incorporate the tropical flora and fauna he saw there into his famous series of jungle scenes, of which this is the first. Even pot plants make it in: there's a domestic rubber plant at the bottom right, scaled up to give the scene its exotic quality. Rousseau's painting is a fantasy of foreignness, built of a combination of the ordinary and the imagined. That flat, pattern-like quality gives it an otherworldy, almost dreamlike appearance.

Greens of every possible shade dominate the painting, from the yellow-green fronds that are whipped by the breeze to the darker greens, tinged with brown, of the bowing trunks and the paler grey-greens of the distant trees. In the greyish sky beyond, wiggling lightning strikes the ground and over the entire painting, most visible against the darker greens of the trees at the top left, are fine grey streaks representing a tropical downpour. The tiger, caught in a crouch, is isolated at the heart of this wild storm. Its snarling jaws, waving whiskers and startled expression will be familiar to any owner of a domestic cat confronting a thunderstorm or fireworks display. Perhaps the surprise of the title is not that of the human, suddenly faced by a dangerous beast in the midst of its territory, but of the animal itself, cowering against the unbridled force of the storm.

1891

The Water-Lily Pond

Claude Monet

1899

Claude Monet's painting plunges us into the heart of a lush ornamental garden on a hot summer's day. Sunlight sparkles across the canvas, a rich green scene made all the deeper for the pink notes of the water lilies in full bloom and blue points suggesting shade. Those powerful greens are created with emerald green paint, popular with artists since its invention in the early nineteenth century despite its high toxicity. The synthetic pigment, made partly of arsenic, may have contributed both towards Monet's eventual blindness and Van Gogh's psychological breakdown, but the brilliance of its hue kept it in use even until the mid-twentieth century.

The setting is Monet's garden at Giverny, where he lived from 1883 until his death in 1926. This garden is one of the legendary locations in the history of art: Monet conceived and designed it himself. The garden, and especially the water-lily pond, provided enough material to sustain his painting career for the rest of his life. His great series of water lilies, of which there are approximately 250 paintings, some large enough to fill an entire wall of a gallery, are testament to the endless inspiration and variation that's possible from just one scene.

Notable in this painting is the almost total absence of dark colours; even the shadows have a vibrancy. One of the key themes of the Impressionists, of which Monet was a founding member, was light and its qualities, which they sought to capture on their canvases, often working *en plein air*. This painting, with its bright colours and delicate contrasts, seems to gather and reflect light, shimmering through a symphony of greens conjuring the meditative tranquillity that Monet himself must have experienced as he made this painting.

SEE ALSO
Poussin,
Renoir,
Rousseau

Self-Portrait with Thorn Necklace and Hummingbird

Frida Kahlo

1940

Although the structure of this painting is that of a conventional self-portrait, Kahlo uses the form to express much more than just physical reality. Painted after her divorce from her fellow Mexican painter Diego Rivera in 1939, and prior to their remarriage in 1940, the symbols that fill this painting hint at Kahlo's heartbreak. The hummingbird that hangs around her neck was a good luck charm, used to bring luck in love; the fact that it is dead and black suggests an ironic reading. The black cat at one shoulder and the monkey, tightening the necklace, at the other, are both traditionally symbols of evil and misfortune. The monkey may have been a pet from her ex-husband, and may represent Rivera himself. Like Christ's crown of thorns, her necklace references physical pain, a theme often present in Kahlo's work, as she began her life as a painter while bedridden after a horrific streetcar accident.

SEE ALSO,
Antonello,
Moroni,
Baldovinetti

 Plants and nature were a steady source of inspiration throughout Kahlo's career, but perhaps especially so at the time this painting was made, when Kahlo was increasingly confined to her home as her health gradually worsened. Her studio overlooked the garden, and she undoubtedly took joy in nature's forms and colours. The plant-insect hybrids around her head are playful touches, contrasting her sombre expression. Here, colours have a compositional role, but Kahlo also used colours for their symbolic meanings, as she recorded in her diary. And despite the vividness of the colour, Kahlo associated leaf green with sadness, suggesting a more complex relationship with nature than one of simple pleasure.

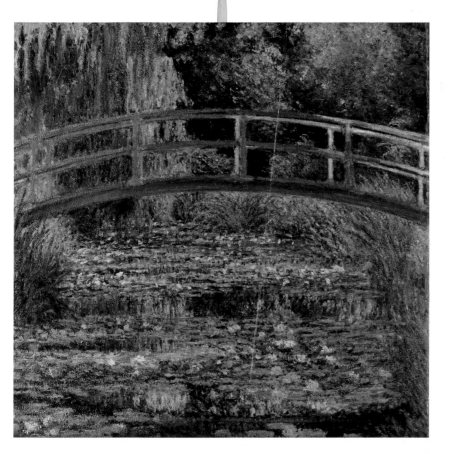

1940

Self-Portrait with Thorn Necklace and Hummingbird, 1940
Frida Kahlo, 1907–1954
Oil on canvas, 61.3 cm x 47 cm
Held by the Harry Ransom Center,
University of Texas at Austin

1899

The Water-Lily Pond, 1899
Claude Monet, 1840–1926
Oil on canvas, 88.3 x 93.1 cm
NG4240

1434

Portrait of Giovanni(?)
Arnolfini and his Wife
1434
Jan van Eyck, active
1422; died 1441
Oil on oak
82.2 x 60 cm
NG186

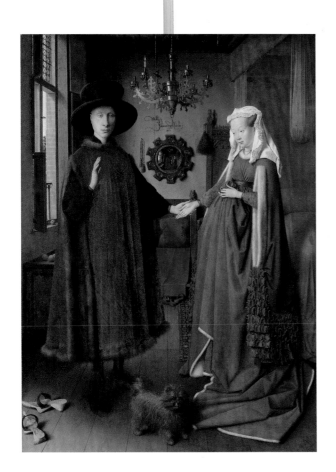

1470

Saint George and the Dragon, about 1470
Paolo Uccello, about 1397–1475
Oil on canvas, 55.6 x 74.2 cm
NG6294

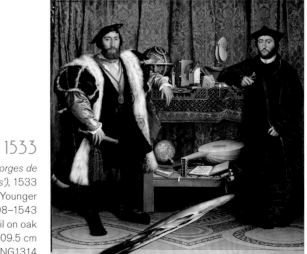

1533

*Jean de Dinteville and Georges de
Selve ('The Ambassadors')*, 1533
Hans Holbein the Younger
1497/98–1543
Oil on oak
207 x 209.5 cm
NG1314

1552

The Death of Eurydice
about 1552–71
Niccolò dell'Abate,
about 1509/12–1571
Oil on canvas
189.2 x 237.5 cm
NG5283

1715

The Scale of Love, 1715–18
Jean-Antoine Watteau, 1684–1721
Oil on canvas, 50.8 x 59.7 cm
NG2897

1619

Still Life of Flowers in a Wan-Li Vase, 1619
Ambrosius Bosschaert the Elder, 1573–1621
Oil on copper, 68.6 x 50.7 cm
Rijksmuseum, Amsterdam, The Netherlands

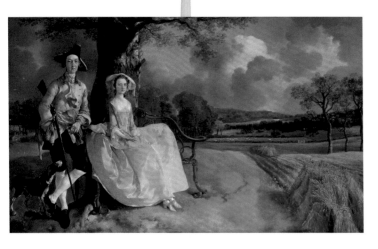

1750

Mr and Mrs Andrews, about 1750
Thomas Gainsborough, 1727–1788
Oil on canvas, 69.8 x 119.4 cm
NG6301

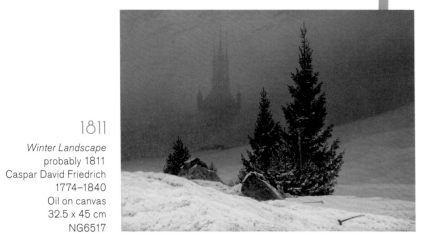

1811

Winter Landscape
probably 1811
Caspar David Friedrich
1774–1840
Oil on canvas
32.5 x 45 cm
NG6517

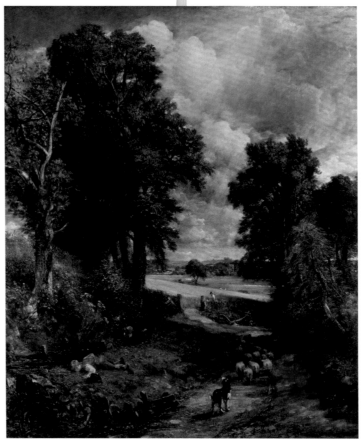

1826

The Cornfield, 1826
John Constable, 1776–1837
Oil on canvas, 143 x 122 cm
NG130

1891

Surprised! 1891
Henri Rousseau, 1844–1910
Oil on canvas, 129.8 x 161.9 cm
NG6421

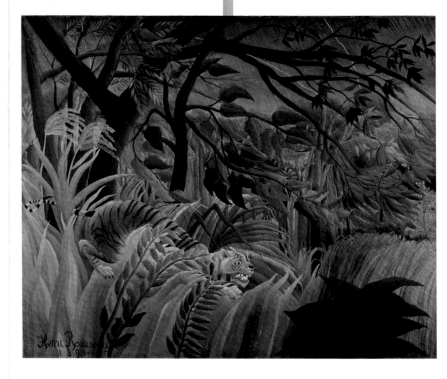

GOLD

Gold radiates divinity and luxury

As both a precious material and a radiant yellow colour, gold has proved irresistible since humans first set eyes upon it. Its rarity and natural brilliance have made it a desirable material for the homes, tombs and trappings of the powerful for centuries. Because of its malleability, gold is a particularly adaptable material, and can be bent into jewellery, engraved with pattern and hammered into paper-thin sheets to make gold leaf. Paintings with expanses of gold leaf, painstakingly applied to a prepared ground, would themselves seem like precious objects. Their glittering surfaces, emphasised through meticulously patterned areas, would reflect upon the wealth of their patron, and give the painting an almost mystical illumination in the gloom of a chapel.

Far more than its luxurious connotations, gold also boasts otherworldly associations. From ancient times, its reflective qualities have made it seem to possess the same power as the sun, traditionally an object of worship, and so it was used to represent divine power in sculptures and paintings for thousands of years. In medieval painting, gold's natural radiance retained its spiritual suggestion. By the Renaissance, though, artists distinguished themselves from their peers by using paint to suggest gold, rather than applying the real thing. Being able to convince people that painted gold was genuine showed exceptional skill. Later, artists used dazzling yellows, combined with colours that exaggerated their intensity, to give their paintings the blazing effect of real gold.

The Wilton Diptych

English or French (?)

about 1395–9

Unlike many other paintings from this time, on display as large altarpieces in churches or chapels, this small two-part painting was intended for one pair of eyes only. The diptych resembles a book: it would have been folded shut and carried while travelling, then opened in a private room and, flanked by candles, set up for prayer. And the person praying was Richard II, the king of England: that's him kneeling at the front of the left-hand panel.

The two panels show different realities: earth on the left and heaven on the right. Three saints – John the Baptist, Saint Edmund and Saint Edward the Confessor – stand behind the king, gesturing to where the Virgin Mary and ranks of angels in brilliant blue fill the scene. The kneeling Richard holds his hands open, waiting to receive the flag of England, which has been blessed by the infant Jesus.

The artists who worked on this panel would have specialised in gold craftsmanship, employing an impressive range of techniques. The oak panels were made into a flat surface using layers of gesso (plaster), then painted with bole, a sticky red clay-like substance. Small squares of gold leaf were carefully applied and gently smoothed flat in a process called burnishing. Behind the figures in both parts of the painting, you'll notice a complex pattern in the gold; this would have been made using a punch. In the crowns of the saints and the king, by contrast, the gold has been built up into a three-dimensional surface using gesso and more layers of gold leaf. This sort of intricate work is called tooling. It's used here to create an even more dazzling jewel-like effect when the light catches the gold. Once opened, the diptych would have glowed and sparkled in the candlelight before Richard's eyes.

SEE ALSO
Duccio,
Sassoferrato,
Rothko

1395

Portrait of a Lady

Alesso Baldovinetti
about 1465

During the Renaissance, it was not unusual for sitters to be depicted in profile. The allusion is to the faces of emperors on Roman coins, then fashionable to collect, which bring with them associations of power that flattered the subject. The effect, though, can sometimes be slightly cold and impersonal. Here the painter has included just enough hints of personality for the woman to come alive.

She's shown from the elbow up, allowing her to display all the characteristics that make her an archetypal beauty of her place and time. In Florence, where this unknown woman lived, lightness of skin and hair and a high forehead were considered especially attractive. To achieve the standard of beauty, she would have powdered her face and shaved her hairline to make it higher. Her tumbling golden hair, an unusual colour for Italians, might well have been dyed – urine, among other things, is known to have been used at the time for this purpose. Baldovinetti uses an almost monochrome palette: except for the flash of pink in the skirt of her gown, the white pearl at her throat and the black band around her exceptionally high brow, his sitter is dressed in various shades of gold. In painting her so, he is ostentatiously drawing attention to the trappings of her wealth and beauty. By setting her against a flat blue background, the artist heightens this glowing effect.

SEE ALSO
Bellini,
Moroni,
Raphael,
Kahlo

Her ornate dress and fine jewellery suggest the woman's noble status, but the prominent device of three palm leaves on the shoulder of the garment remains mysterious. Perhaps it represented a family crest. The lady's identity is unknown, but look closely at her face – that very slight movement of the lips, her steady and somewhat ironical gaze – and her character shines through.

Saint Michael Triumphs over the Devil

Bartolomé Bermejo

1468

This golden painting is a single panel from a much larger altarpiece made for a church in Tous, near Valencia, in southern Spain. In the background, gold leaf has been carefully applied to a red bole surface. The artist has then worked into it with a punch to create a complex pattern that would have glinted in the candlelight of its original location. Dominating the painting is the figure of the Archangel Michael, who can be identified by his wings, his sword and the delicate lines of gold that radiate from his head. He is shown in golden armour encrusted with precious gems, especially around the ankles. His breastplate reveals a reflection of the Heavenly City, whose troops Michael leads.

Sword raised, Michael prepares to strike the figure of Satan skulking at his feet. Bermejo has fused different parts of real animals to create this fiendish creature: it has the legs of a chicken, the wings of a bat, the teeth of a shark and the wing patterns of a butterfly. The effect is perhaps not as menacing as was intended. On the left-hand side of the painting, there's a kneeling figure who seems totally unaware of the violence unfolding next to him. This is the painting's patron, Antonio Juan, Lord of Tous. Juan is shown holding a book of psalms, with a huge sword leaning against his

SEE ALSO
Antonello,
Holbein,
Uccello,
Rousseau

elbow. This combination of the spiritual and the military makes the painting very much of its time and place. It was painted during the period known as the Reconquista, or 'reconquering', when the Christian monarchs of Spain were attempting to recover territories taken by the Moors. The presence of armour and weaponry would have been understood then as a reference to their ambition.

The Family of Darius before Alexander

Paolo Veronese

1565–7

This huge painting has all the qualities of a grand theatrical production. Extravagant costumes are everywhere to be seen, and the characters' gestures are highly exaggerated, more reminiscent of stage acting than of real life. There's even a kind of set, with the row of classical-style arches and banisters behind the action looking very much like a painted backdrop. The artist specialised in such scenes and was hugely popular among the patrons of his adopted city, Venice. Opulence was key to Venetian architecture and design, with gold mosaic pattern, inherited by the Byzantine empire, a notable feature of its native style. It's present in this painting, too, with gold accents sparkling in the costumes of the princesses, and the golden details on the armour and weaponry. The splendour of the jewellery and costumes of the figures in paintings by Veronese was such that in 1650 the writer Marco Boschini claimed that the artist had 'mixed gold with pearls, rubies, emeralds and sapphires' to make his paint.

SEE ALSO
Canaletto,
Moroni,
Titian

The painting is based on an episode in the life of Alexander the Great. Having defeated the Persian king Darius, Alexander and his troops descend upon the castle where Darius' family await their fate. When they enter, the king's mother makes a potentially fatal mistake: she kneels before the wrong man. Shown at the centre of the painting in blue, her face is a mask of panic. Her mistake is understandable, though. If you look at the two men – Alexander in pink armour with gold details, stepping forward to correct her, and his right-hand man, Hephaestion, whom she has mistaken for the emperor, in an orange cape – they do have remarkably similar faces and haircuts.

The Adoration of the Golden Calf

Nicolas Poussin

1633–4

In this painting, Poussin tells an Old Testament story of the Israelites. Freed from slavery in Egypt, at the foot of Mount Sinai, their tents are pitched at the base of the cliffs. Their liberator, Moses, has been called by God to ascend the mountain, and while he is gone, the restless Israelites have called upon Moses' brother Aaron to make them a god to worship. Aaron has collected the gold jewellery of the freed slaves, melted it down and cast it into the golden animal upon the pedestal being worshipped by the people below.

Poussin depicts the critical moment when Moses then returns with the two tablets of the Ten Commandments – the first and second of which forbids the worship of other gods and creating images of them. Furious, he will burn the idol and grind it to powder, then scatter the powder in water and force the Israelites to drink it as punishment. In Poussin's painting, that hasn't happened yet. Instead, most of the worshippers remain unaware of Moses' anger, though a few have noticed the distant figure on the mountainside, dashing one of the tablets on the ground in anger. Behind the pedestal, two women turn their heads, and next to the man in the white hooded robe – this is Aaron, Moses' brother – is a woman shrieking in panic. For Poussin's clientele, this narrative was a reminder of the dangers of heresy, as well as a parable about materialism: the golden calf is the embodiment of self-indulgent luxury. Freezing the narrative immediately before its brutal culmination, Poussin's painting generates a thrilling tension, the dark clouds gathering overhead against a golden sunset, adding emphasis to the imminent conclusion.

SEE ALSO
Claude,
Constable,
Cuyp

1633

Belshazzar's Feast

Rembrandt
about 1636–8

In medieval times, most artists simply applied actual gold leaf to the surface of their work. From the Renaissance, however, artists began to attempt to paint the effects of gold, which was a lot less expensive than using the real thing, and when done well could be just as convincing. The challenge also tested their abilities as a painter. Rembrandt's painting, filled with shimmering golden objects and clothing painted using browns, yellows and oranges, is a showcase for the artist's talent, as well as an intensely dramatic and exciting interpretation of a biblical story.

When Rembrandt made this painting, he was at the very height of his fame as an artist. Revered for his ability to capture convincing human expression and his command of storytelling, Rembrandt was at this time the most successful artist in the United Provinces (now the Netherlands). The painting depicts the moment when Belshazzar, the last king of Babylon, is visited by the hand of God in the middle of a lavish feast. The centrepiece is an arrangement of flamboyantly expensive gold and silver cups, platters and cutlery. Their glinting surfaces are echoed in the gold thread embroidered into dresses and hats and capes, a golden crown sitting on a turban, golden jewellery sparkling in the darkness, and, most importantly, golden Hebrew letters, written by a spectral hand, that blaze against the dark stone wall. Draped in a gold-brocaded fur-lined cape, wearing a teetering turban topped with a jewel-studded gold crown and gold-clasped feathers and dripping in golden jewellery, Belshazzar himself is the embodiment of self-indulgent materialism. His bulging belly, against which his gold necklace sways and slaps, is another indication of his hedonism: this isn't his first feast. The king leaps up, eyes bulging, and with an outstretched arm knocks a goblet into the lap of a gap-

toothed old man. His guests react in varying attitudes of confusion and shock: those who can't see the letters for Belshazzar's towering turban look on, bewildered; another woman, pouring wine, drops her cup but keeps pouring from a decanter. Rembrandt freezes the action at the moment of dawning realisation, suspending the story's resolution to retain its dramatic charge.

'Mene, Mene, Tekel Upharsin', reads the text on the wall: 'you have been weighed in the balances and been found wanting'. The light shining from the letters illuminates Belshazzar like a police searchlight, picking out every detail of gold that surrounds him or he wears upon his body. Gold, after all, is the source of the king's crime – namely those cups and platters that the group is drinking and eating from, which are stolen goods, sacred vessels

SEE ALSO
Kalf,
Veronese,
Rubens

seized by his father, Nebuchadnezzar from the temple in Jerusalem. Used in sacred services, their repurposing as means of excessive indulgence is the source of the divine wrath. This feast is not only gluttonous in the extreme, it is also sacrilegious. That night, Belshazzar will die, and his kingdom will fall.

Though biblical in origin, drawn from the Book of Daniel, Rembrandt's painting is no altarpiece to be prayed in front of and was painted to be sold on the open market. Rather than serving as religious instruction, it is a virtuoso display of Rembrandt's skill. At a time when the ultimate test of an artist was their ability to depict real textures and surfaces, Rembrandt shows off with all that gold shining out through the gloom. As well as his technical abilities, it also flaunts his skill as a storyteller: he revels in the shock and awe rippling across this frozen moment unfolding.

River Landscape with Horseman and Peasants

Aelbert Cuyp

about 1658–60

Viewers familiar with the landscape of the Netherlands might find this painting depicting a rural setting to the south of the country slightly puzzling at first. The country is not known for its gentle golden light, or indeed for its mountainous terrain, and yet both are present here. The painter, Aelbert Cuyp, was exceptionally successful in his time as a painter of his native land because of – not in spite of – these unusual and fictitious elements in this and other paintings. Combining the real and the symbolic was what made Cuyp's paintings so loved in his lifetime and beyond.

As with so many paintings made in the Netherlands at this time, the scene is everyday, not biblical or classical. The rising sun casts golden light over a rural scene. At the edge of a tranquil lake, a small herd of cows, and beyond them a flock of sheep, are being tended. On the lake's far side are the spires and turrets of a small town, nestled at the foothills of a range of mountains. The hunter, crouching behind a bush, taking aim at the ducks that glide across the water, may soon shatter the peace, but for now all is quiet and calm. The effect is of a suspended silence, like a held breath.

Landscapes such as this, full of carefully observed natural details, would have appealed to Cuyp's patrons, who lived in grand houses in the affluent cities of the Netherlands. Their country had, within living memory, established its independence from Spain and become one of the wealthiest in Europe, with trading posts scattered across the world as far afield as Indonesia and the Americas. An influx of exotic luxury goods made their economic success tangible. When this painting was made, the country was reaching the apex of

its wealth and power. The fact that this extraordinary success came from a country that had literally been made by their ancestors from scratch – much of the Netherlands is reclaimed land that had once been underwater – made paintings of rural scenes more than mere decoration. The cows resting by the water are a symbol of this, themselves being an important source of the country's wealth, but also representing the viability of its idealised green pastures, the richness of this land.

The inclusion of mountains and the incongruous golden light that mark this scene out as unusual are in part the legacy of Dutch painters who had travelled across the Alps to Italy and brought back a trademark style of lighting, influenced by Claude, as well as features of the landscape.

In Cuyp's paintings especially, all these details work on a symbolic level too, drawing associations with previous apogees of western civilisation. Far from the clear, cold light of northern Europe, this is the hazy, sensual light of the Mediterranean, and the gentle illumination of the scene creates a bucolic atmosphere calling to mind the notion of Arcadia – an Eden-like paradise of Ancient Greece in which man and nature supposedly lived in harmony, much like the concept of the Golden Age, described in classical poetry. Cuyp's patrons – themselves often landowners who'd grown wealthy through farming – would have appreciated his depiction of the source of their prosperity within a celebration of an idealised national identity.

SEE ALSO
Claude,
Kalf,
Rembrandt

1658

Psyche showing her Sisters her Gifts from Cupid

Jean-Honoré Fragonard

1753

1753

Fragonard's painting, made when he was in his early twenties, typifies the heady, dreamlike sensuality of his work. It depicts a moment taken from the Roman writer Apuleius' *Metamorphoses*, in which the beautiful mortal princess Psyche shows her sisters presents she has been given by her lover, the god Cupid. Since the novel's rediscovery during the Renaissance, the story of Cupid and Psyche had been a favourite among patrons of artists seeking romantic imagery for private commissions. In Fragonard's interpretation of this scene, golden objects abound, from the throne on which Psyche sits to the tassels of the vast pink carpet at the bottom of the painting, to the lush colour palette of gold, orange and rose pink. Smoke curling from a golden incense burner gives the scene a hazy languor that will characterise Fragonard's paintings from this moment on.

SEE ALSO
Niccolò,
Titian,
Watteau

Understandably, Psyche's sisters are dazzled by all this opulence; they stand and stare. The presence of Eris, goddess of discord and strife, who floats over the sisters' heads, her hands clutching squirming snakes, hints at the danger to come. The envious sisters will pester Psyche with questions about her lover, who is represented in the painting by his abandoned quiver of arrows. Every night, Psyche visits Cupid in his enchanted castle, but always on the condition that there must be total darkness, because Cupid doesn't want her to see who he really is. Consumed by curiosity and egged on by her sisters, Psyche finally brings an oil lamp with her one night – whereupon Cupid is revealed and the castle instantly vanishes.

The Duke of Wellington

Francisco de Goya

1812–14

This is a portrait of Arthur Wellesley, the Duke of Wellington, painted by the most celebrated Spanish painter of the day, Francisco de Goya. Due to his stern single-mindedness, one of Wellesley's many nicknames was 'The Iron Duke' – but this portrait shows a different aspect of his character. Wellington sat for this portrait in 1812, after he had successfully liberated Madrid from Napoleon's troops, and three years before his decisive victory over Napoleon at the Battle of Waterloo. The gold medals on his chest mark him out immediately as a military hero. The Duke was a member of three military orders: the British Order of the Bath, the Portuguese Order of the Tower and Sword, and the Spanish Order of San Fernando. Hanging from the pink silk sash is the military Gold Cross, awarded two years after this portrait was made and added later by the artist.

Yet Goya's fame rests not on his ability to merely evoke the prestige of his sitter but on his penetration of their innermost character. Wellington's lips are very slightly parted, showing the gap

SEE ALSO
**Bellini,
Antonello,
Zoffany**

between his teeth. There is a faint sheen of sweat around his chin and mouth, suggesting the discomfort caused by the heavy dress uniform in the oppressive heat of a Madrid summer. These elements are not intended as an ironic contrast to the glorious golden medals, but instead are there to emphasise the Duke's ordinary humanity. As with all great portraits, it derives its energy from the way it is able to capture the experience of how it was made: a military hero, sweating as he sits for an artist who observes his foreign subject with an unwavering but sympathetic eye.

1812

The Fighting Temeraire

Joseph Mallord William Turner

1839

Although Turner's painting is based on real events, he has taken considerable poetic licence with the facts. In the scene, a badly damaged warship, the *Temeraire*, which had fought heroically in the Napoleonic Wars, including at the Battle of Trafalgar – in which it had valiantly come to the rescue of Nelson's own ship, the *Victory*, helping ensure the British fleet was triumphant – is being dragged to the docks at Rotherhithe, on the Thames, where it will be broken up. The ship took a huge amount of wood to build (some 5,000 oak trees), so it will not be allowed to go to waste. Some parts will be recycled, used in other boats or for furniture. The white flag hanging on the mast of the tug indicates that the ship it tows no longer belongs to the Royal Navy, but has been sold to a merchant, a civilian now.

SEE ALSO
Constable,
Gainsborough,
Monet,
Rothko

For Turner, who probably did not witness the scene himself, this was much more than the final episode in the life of a great ship. For him, the destruction of the *Temeraire* meant the end of Britain's naval power, as well as the ending of the age of the sail ship in favour of steam-powered vessels. Here, his ability to bring together careful observation – especially of light and its relationship with water, which was one of his principal preoccupations as a painter – and heightened or imagined elements results in a painting that is both naturalistic and deeply symbolic, and most of all highly expressive.

The painting is split in half. On the left, the dark steam tug, belching dirty red smoke, makes the pale, elegant warship behind it seem even more ghostly by contrast. The grand old ship almost

disappears before our eyes, fading into the pale purples and pinks of the sky behind. In the sky above, a silvery moon – a symbol of the night and of death – rises, its white reflection rippling on the water below. On the opposite side, the sun is setting over the distant spires of London.

In reality, the boats would probably have set out at daybreak, and if this had actually taken place at sunset they would have been heading in the wrong direction, but this is just one example of a number of details the artist chose to alter for the sake of the aesthetic. (In fact the *Temeraire* was tugged by two boats, not one; and most of the ship, certainly including its masts and sails, would already have been stripped.) But Turner, like so many Romantic poets, saw the sunset as a symbol of the passing of time and the inevitability of death, and he has created a sky full of emotional resonance. The resplendent sunset takes over the right-hand side of the painting, depicted in a glorious palette of intense gold, from the lightest yellows and brightest oranges and reds and ruddy browns, setting fire to the water directly below, and fading to a more naturalistic brown and grey in the waters around the two vessels. The incandescent colour scheme is mirrored in the approaching tug and its vivid reflection in the strangely still water. Oranges, golds and browns give the painting an autumnal palette that echoes the melancholy pervading the composition, while on the other hand the dominating gold and the splendid sunset can be seen as a fitting tribute and elegy for the august ship. The specific event takes on a universal significance, expressing an emotional truth we all experience in different ways.

Sunflowers

Vincent van Gogh
1888

Van Gogh's paintings took as their subjects the most ordinary things imaginable: an old pair of boots, the local postman, fields of wheat or flowers in a vase. The artist, however, located a natural spirituality in the humblest objects and settings. His works attempted to represent a modern kind of religious painting, and so this painting, depicting sunflowers stuffed roughly into a terracotta vase, was much more than the sum of its parts. The sunflowers spring and sag from the lip of the vase, on which the artist has signed his first name in bright blue, like a decorative pattern. The background of the painting is divided into two areas of powerful colour: bright light yellow in the top three quarters and ochre in the bottom. The flowers' hard outlines and the rather flat areas of colour are testament to Van Gogh's fascination with Japanese woodblock prints, which at the time were making their way into France on cheap wrappings for imported porcelain. A wide variety of yellow tones makes the painting a symphony of radiant golden yellows. The accents of blue serve to intensify the yellows by contrast, making the painting almost literally radiate light. In this way, the yellow background serves a similar purpose to the flat areas of gold leaf used in medieval religious paintings. It could be a kind of modern icon. That Van Gogh began his career as a trainee minister should come as no surprise.

SEE ALSO
Kalf,
Renoir,
Bosschaert

Although all of his major works were made in southern France, Van Gogh's identity as a Dutchman remained important to him. The focus on everyday subject matter was something especially associated with Dutch artists of the Golden Age two centuries previously. For Van Gogh as for them, arrangements of organic objects acted as metaphors for the passing of time: because they rot

and decompose, they symbolise the natural life cycle of all things, including the human form. These flowers are shown in various stages of decay, which suggests this metaphorical level of meaning. Yet sunflowers were also a symbol of devotion and happiness in Dutch literature, a meaning with which Van Gogh would certainly have also been familiar.

A few months before making this painting, Van Gogh had arrived in Arles in the South of France with the intention of inviting fellow artists to join him to form a new kind of artistic colony, which he called 'the Studio of the South', inspired by what he knew of working practices in Japan. He rented a building known as the Yellow House, which would form the hub of this group, and invited the French painter Paul Gauguin, a hero of his who he had met in Paris, as the first artist to join him there. He then carried out two paintings of sunflowers to decorate Gauguin's bedroom in the Yellow House. It may have been Van Gogh's flattery to the more successful Gauguin in choosing a sunflower as the theme of these paintings, since a sunflower follows the path of the powerful sun across the sky. The painting seems to brim with the light of Provence, like an open window on a summer's day. Gauguin arrived in the autumn of 1888 and portrayed Van Gogh painting sunflowers in one of his portraits of his friend. Although the two men famously fell out not long afterwards, the following year Gauguin asked Van Gogh to paint another version of the composition and send it to him in Paris as a memento of their time together. In total, seven versions of the subject exist, some for him to keep, some to give away to family members or friends. They are now in collections all over the world.

The Kiss

Gustav Klimt
1907–08

Gustav Klimt's training as an architectural decorator in Vienna had resulted in early commissions for large-scale paintings on walls and ceilings. He was inspired by the church interiors he saw in Venice and Ravenna on a visit in 1903, which feature fields of golden mosaic that create surfaces of glittering light. Although comparatively small, this painting brims with gold leaf ornamentation, testifying to the artist's intention to create a secular icon painting for the modern age. Klimt's 'Golden Phase', of which this painting is one of the most celebrated examples, juxtaposes naturalistic content, often sensual images of women, with elaborate passages of decoration in patterned gold.

Klimt depicts the couple in *The Kiss* as a single entity, with only the different patterns of their garments to distinguish their two bodies. The entirely flattened background, flecked with gold leaf, seems to position the couple on the edge of some infinite space, while the ground on which they kneel, with its intricate floral design, binds them to the organic world. Crowned respectively in green vine leaves and star-like flowers, the male and female figures cling together, his neck thrusting forward to kiss her cheek to suggest urgent passion. Her closed eyes, limp right hand and beatific expression imply erotic abandon, so that the swirling patterns that surround her like a golden cloud seem to

SEE ALSO
The Wilton
Diptych,
Watteau,
Kahlo

mirror her emotional state. The flatness of medieval art and mosaic pattern places the composition outside of conventional experience, but the spiritual dimension that gold has in such contexts is largely absent in Klimt's painting. Instead, the painting seems a celebration of sensuality and physical intimacy, in which gold stands for a transformative, overwhelming, yet utterly bodily experience.